SECRET NEATH

Robert King

AMBERLEY

This volume is dedicated to my late uncle, Edward John King of Rectory Road, who was one of the first to slake my thirst about the town's history by relating stories of its past; also to the late Clive Trott, esteemed headmaster of Rhydhir Secondary Modern School, who began, and continued, to put it in order.

First published 2017

Amberley Publishing
The Hill, Stroud
Gloucestershire, GL5 4EP

www.amberley-books.com

Copyright © Robert King, 2017

The right of Robert King to be identified as the Author of this work has been asserted in accordance with the Copyrights, Designs and Patents Act 1988.

ISBN 978 1 4456 6628 0 (print)
ISBN 978 1 4456 6629 7 (ebook)

British Library Cataloguing in Publication Data.
A catalogue record for this book is available from the British Library.

Origination by Amberley Publishing.
Printed in Great Britain.

Contents

Acknowledgements

I'm indebted to Mike Davies for many of the pictures that appear in this book; to James Rees for his information on the Castle Hotel; to Richard Dyer for keeping my computer active; to George Brinley Evans for his knowledge on St Patrick and the Banwen Connection and for his guidance regarding the author Bert Coombes; for unfailing support from Barrie Flint and Glyn Williams; to Harriet Eaton for her help in searching out historical information from the archives of the Neath Library; to Sarah Maybery Thomas who started the historical walks that make up part of this volume and Cheryl Hadley and Jeff Griffiths whose support and enthusiasm is unending. Lastly, but they should be first, my gratitude to Joy, my wife, for putting up with me, and Becky Cousins, my editor, whom I probably drove to distraction.

Introduction

Secrets are not secrets to everyone, particularly when we come to aspects of local history. We all have our favourite periods, those times we find of greater interest than others, whether it's the period of the Roman occupation or the development of the borough as the Normans started to lay the town by building its castle and St Thomas' Church and the long-lost town wall, or the more recent Victorian and Edwardian developments from the 1830s to the 1930s. There are the epidemics that blighted the town and the installation of sanitation and clean drinking water, and how the streets were constructed, the buildings that occupied them and the people who lived in them or used them for business purposes.

For others there is the ecclesiastic life of the town from the churches to the places where dissenters worshiped God, the oldest – St Thomas' and St Illtyds' – and Llan Gatwg to the Quaker movement in their Meeting Place on the Latt to the nonconformist chapels that abound the area today (albeit in lesser numbers than in the past), and the Catholics who have for many years worshipped at St Joseph's.

The flavours are many and many of us like all its tastes.

1. Nidum: A Roman Town

Remarkably, it wasn't until 1949 that historians discovered part of the Roman settlement in Neath, when the local authority was building the houses that ultimately became Roman Way. Historians knew that a Roman settlement existed somewhere in Neath, and now, after more than 1,500 years, it had been found. What we have remaining to remind us about the Roman beginnings of the town are the two gatehouses nearest the river; Blaen Cwm Bach, the marching camp on Heol Morfydd, which is said to have housed some 3,000 legionnaires; and the fort and marching camp between Banwen and Coelbren. But nearer the town, the crossing just above the Neath river bridge is the most surprising remnant of our Roman past: a superbly constructed stone pavement, enabling the people of that time to cross the river with relative safety. I was shown this example of engineering in the 1960s by my old headmaster, the late Mr Clive Trott. The crossing can be seen at a very low tide, as depicted in the picture. We were not just shown it but actually walked across it, wearing Wellington boots and carrying a stout stick for balance, as Mr Trott said. The water came only part way up the boots and climbing out of the river on the town side was a little trickier, but we negotiated it without mishap. Today it would be more difficult

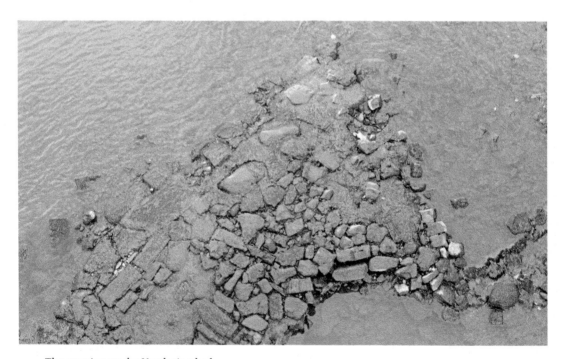

The crossing on the Neath riverbed.

because of the silting on the riverbanks. Nevertheless, we were fortunate to experience the feat notwithstanding health and safety regulations that prevent such endeavours today. Despite the 2,000 years since the stones were laid they remain in perfect, workable condition today.

One can conjure up the scene with Roman gallons being rowed out of Swansea Bay, into the mouth of the River Neath and upwards to the site of their fort (with no road, railway or canal in place), those huge ships docking to unload the materials and wares needed for the development and continuing life of the occupation.

The forts were built to subdue the local population and to exploit the natural resources the country had to offer. The tribe in our area – covering what is roughly Glamorgan and Gwent today – at the time of the occupation was the Silures, and by the time Nidum was established they had been eradicated. The Silurian leader was one Caradog – called Caratacus by the Romans – and he had been captured with his family and taken to Rome by AD 51. (For reference to Caradog's children see Timothy 11, verses 19–21 in the Bible. Linus was his son, and Claudia his daughter. The latter married Rufus Pudins, who converted to Christianity after meeting Claudia. He is reputed to have been present at Christ's crucifixion. It's heartening that these people walked and rode their horses in our area and then ended up in the scriptures.)

DID YOU KNOW?

When the American Army joined the Allies during the Second World War they selected a site in Banwen to serve as a camp for its soldiers. Unbeknown to them, it was the same piece of land the Roman's had used as a marching camp nearly 2,000 years earlier – military minds think alike!

2. St Patrick

We are still in the period of the Roman occupation when a young man who became St Patrick was born in Banwen – that's the assertion that those of us who are deeply interested in local history make, and none more so that George Brinley Evans, the author who lives in Banwen and has written extensively on the subject.

What leads us to this belief is taken from St Patrick's deathbed confession: 'I, Patrick, a sinner, a most simple countryman, the least of all the faithful and most contemptible to many, had for father the deacon Calpurnius, son of the late Potitus, a priest of the settlement of Bannavem Taburniae [near the Roman fort at Coelbren]...'

Patrick says that he was captured by Irish pirates when he was sixteen years of age. Thus his relationship with Ireland began. Considering we believe he was born c. AD 395, it then would have been around c. AD 410 when the Roman occupation of Britain was coming to an end, enabling the marauding Irish to sail up the River Neath as far as Aberdulais and pillage the area without resistance.

In his confession he tells us that he was held captive for some years, then says: 'And after a few years I was again in Britain with my parents and they welcomed me as a son, and asked me, in faith, that after the great tribulations I had endured I should not go anyway else away from them...'

In the traditions and stories related to holy men, he had a vision that mapped out his future life, which continued and culminated in the boy born in Banwen becoming the patron saint of Ireland.

> And, of course, there, in the vision of the night [a dream] I saw a man whose name was Victoricus coming as if from Ireland with innumerable letters and he gave me one of them and I read the beginning of the letter: The Voice of the Irish; and as I was reading the beginning of the letter I seemed at that moment to hear the voice of those who were beside the forest of Foclut which is near the western sea, and they were crying as if with one voice: 'We beg you, holy youth, that you shall come and shall walk again among us.' And I was stung intensely in my heart that I could read no more, and thus I awoke. Thanks be to God, because after so many years the Lord bestowed on them according to their cry.

Some years ago a group of Irish Catholics were staying in Neath and the priest in charge of St Joseph's Church asked me to show them the sites in Neath related to their faith – Neath Abbey, St Margaret's Chapel and Well in Jersey Marine and, of course, Banwen. They were entranced when I laid before them the idea that this is where St Patrick was born. I pointed to a stream that ran past the site of where, we believe, he was born; they rushed to the local shop and bought up all the soft drink bottles, poured out the contents and filled them with water from this stream – a tourist opportunity missed!

SAINT PATRICK

LOCAL LEGEND HAS IT THAT THIS IS THE
BIRTHPLACE OF
MAGONUS SUCATUS PATRICIUS
BETTER KNOWN TO US AS
ST PATRICK.

IN HIS CONFESSION JUST BEFORE HIS
DEATH HE SAYS OF HIMSELF:

I WAS PICKED A STONE OUT OF THE BOG

I PATRICK, A SINNER, A MOST SIMPLE COUNTRYMAN, THE LEAST
OF ALL THE FAITHFUL AND MOST CONTEMPTIBLE TO
MANY, HAD FOR MY FATHER THE DEACON CALPURNIUS,
SON OF THE LATE POTITUS, A PRIEST, OF THE
SETTLEMENT (VICUS) OF BANNAVEM TABURNIAE:
HE HAD A SMALL VILLA NEARBY WHERE I WAS TAKEN CAPTIVE.
I WAS ABOUT SIXTEEN YEARS OF AGE.

PROJECT SUPPORTED BY THE DULAIS VALLEY PARTNERSHIP
AND THE PRINCES TRUST.

The plinth indicating St Patrick's birthplace.

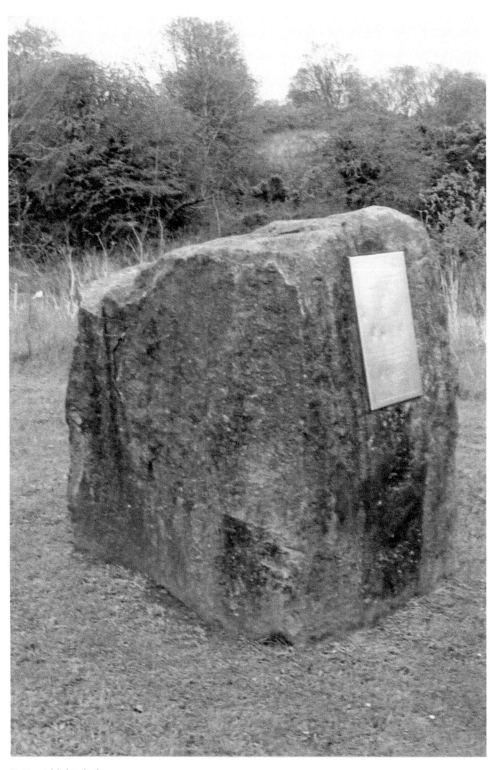

St Patrick's birthplace.

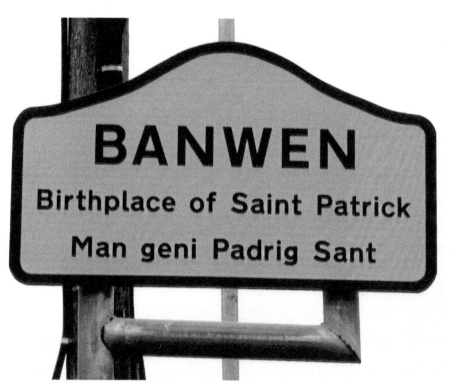

The village sign.

3. Victoria Gardens, Neath

As part of the town's celebrations for Queen Victoria's Diamond Jubilee in 1897, Neath Borough Council decided to create a formally designed public open space. The council owned approximately 2 hectares of land called the Corporation Fields, which was considered a suitable place to develop a park or gardens that could be a peaceful haven for the townsfolk of Neath.

DID YOU KNOW?

A local builder, Mr Thomas John Snow, was commissioned to develop Victoria Gardens. What we see today has changed only slightly from what he originally envisaged and ultimately developed. Additions to Mr Snow's ideas have been added to, such as the placing of the Gorsedd Stones, the Howel Gwyn statue, the drinking fountain, and the memorial to those from the town and its environs who died while fighting for democracy in the Spanish Civil War. The central bandstand, cross of paths, and serpentine perimeter paths are all original facets of Mr Snow's idea and have remained in place since the time when the gardens were opened to the public.

The area of land now occupied by the 'gardens' has had many incarnations. It was the site of the Gnoll Colliery around the seventeenth century, owned by the Macworth family of the Gnoll. It's been called by various names: the Mera Field, the Corporation Field, the Recreation Ground, and finally Victoria Gardens.

In 1856, Neath Council purchased the land known as the Mera Field from Henry John Grant of the Gnoll to enable it to provide an open space in the heart of the town for the use of the growing population. From that time on it was called the Corporation Field and played host to cricket and rugby matches and also was the venue for Neath's annual Great September Fair. The field continued to host the fair until 1897, when a commemoration was planned on the site for the monarch's Diamond Jubilee.

Reference to the Mera Field is interesting. David Rhys Phillips gives us the following description of the origin of Mera and about the people who lived there:

The word Mera is of ancient use for the district around the top of Water Street – probably of marsh designation. Gwyr y Mera – the inhabitants of the Mera: a group of collier

cottages mainly dating from the end of the 17th century. Many of the travelling tinkers and hucksters of the valley were drawn from this place. They came from Shropshire and other parts of England to work at the undertakings of Sir Humphrey Mackworth and the Mines Adventurers, developing in time a Welsh patios which they spoke with a Welsh intonation that wasn't unpleasant. Merched y Mera were the Amazons of Glamorgan. They travelled the valleys on foot, vending crockery, cockles and other wares. Wheugan o ferched y Mera was a phrase for a group of ten.

The reference to Amazons implies that the Mera community was matriarchal and indeed the Neath Antiquarian Society Transactions of 1979 has a picture entitled Nell Downey, the Queen of the Mera.

In 1895, the council had purchased from Evan Evans Bevan, the Neath brewer, twenty cottages called Park Row and the Cross Keys public house that were located on the corner of the field. They were all demolished and the public house was rebuilt opposite the original site and continued to be called the Cross Keys.

The design to turn the Corporation Field into a park was laid by Mr Snow in 1897. At the main entrance, the gate nearest St David's Church, marble pillars were imported from Italy to hold the wrought-iron gates and they were put in place on the actual date that Queen Victoria celebrated her Diamond Jubilee – 22 June 1897. The then mayor of Neath, Councillor Arthur Russell Thomas, officially laid the commemorative stone, which marked the occasion. The expensive Italian marble pillars were a donation from Mr Snow.

The park was known at that time as the Recreation Ground and was made available to the public. During the following months the name Victoria Gardens was decided on and formally opened by Mayor Abraham George Esq, JP, and renamed on 30 June 1898.

A notice of the opening was as follows:

A procession of inhabitants will be formed in front of the Town Hall and march thence to the Victoria Gardens which will then be formally opened to the public.

A band will be in attendance.

The scholars attending various Sunday Schools in the Borough will take part in the procession and passing through the Gardens will proceed to their accustomed playfields where the Mayor will cause a supply of buns to be distributed amongst the children.

Immediately after the opening of the Gardens, the Mayor and Corporation will proceed to Moss House Wood, when the new reservoir, recently constructed by the Town Council will be opened.

All burgesses and inhabitants are heartily invited to attend both ceremonies.

Edwin T. Curtis,
(Town Clerk)

The reference to the Moss House Reservoir is interesting. The Borough Council was forward thinking and many changes were taking place in the town: the Victoria Gardens, the reservoir in Moss House Woods, and the construction of a municipal cemetery at Llantwit – three huge projects that came to fruition literally within months of each other.

The main entrance to the gardens was suitably bedecked in buntings and flags with the great and good of the town in attendance. And on the evening of 30 June 1898 a civic dinner was held in the Castle Hotel to continue the celebrations of the Queen's Diamond Jubilee. At the dinner one of the guests, Alexander Peters, choked to death and he became the first person in Neath to be buried in the Civil Cemetery at Llantwit. Only a few days after attending the opening ceremony at the cemetery, poor Alexander became its first incumbent!

Only one major change has taken place in the gardens since its opening. The area originally included the land occupied by the bus bays. The bays were built in the 1930s, together with two wooden bus shelters and the underground toilets. There were also underground toilets at the entrance near the Cross Keys.

The original construction was circumvented by a low stone wall (still in evidence), with an iron fence on top and then fronted by a low privet hedge.

Following the First World War a tank was lodged in the gardens, near the location of the new Community Building Facility. It was circled by a metal fence with concrete posts, a monument to those from the town who paid the ultimate price in the conflict. A little more than twenty years later the tank paid the ultimate price itself when, following the massive drive for metal to make armaments for use in the Second World War, it was taken for scrap together with the metal railings that had been placed on the low stone wall marking the boundary of the gardens.

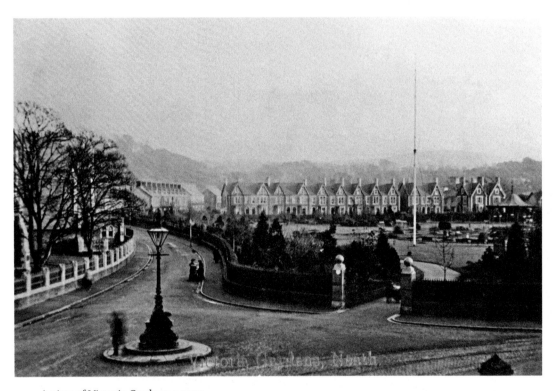

A view of Victoria Gardens *c.* 1920.

Victoria Gardens.

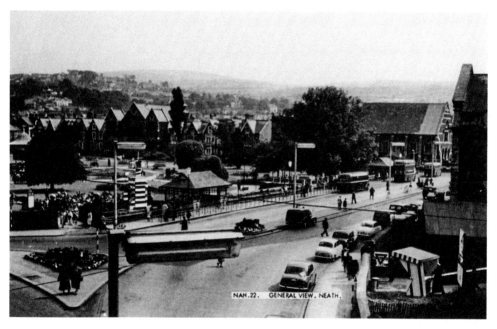

A 1960s view of Victoria Gardens.

The Bandstand

This large octagonal bandstand that has a lead ogee roof with decorative cast-iron pillars and balustrade, and a dressed pennant stone plinth is the most prominent feature in the park. The bandstand was supplied by James Allen & Son from Glasgow at a cost of approximately £175. It was design No. 10 in the catalogue, with the exception of balustrade panels, which were changed to those of design No. 13. The bandstand continues to this day to be used for the purpose it was built – and hopefully for many more. If you look at the base of the columns, you can see the maker's name cast into them.

Howell Gwyn's Statue

This life-sized bronze statue, the only statue in the town, was relocated to the gardens in 1967. Previously it had stood for seventy-nine years outside the Gwyn Hall, with the subject's hand pointing to the house where he had been born. There is now an Argos store on the site, and previous to that F. W. Woolworth occupied the area. It was moved to the gardens because it might have caused, or did, a degree of traffic congestion outside the Gwyn Hall. Howell Gwyn (1806–88) was a benefactor to the town. He was a wealthy landowner who gave the council the land that the Gwyn Hall now occupies. He also donated the land for the building of St David's Church, the Constitutional Club, and Alderman Davies' Church in Wales School, together with land for the building of various chapels in Neath and its environs. His generosity didn't remain in the confines of Neath: he enabled the building of both civic and religious buildings in Breconshire and Carmarthenshire. His political career spanned the whole spectrum of society: in Neath as councillor, mayor, freeman of the borough, chairman of the Board of Guardians; High

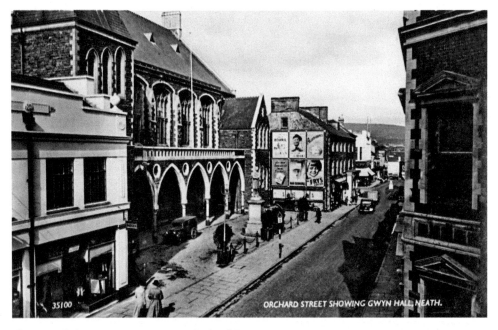

The statue in its previous position on Orchard Street.

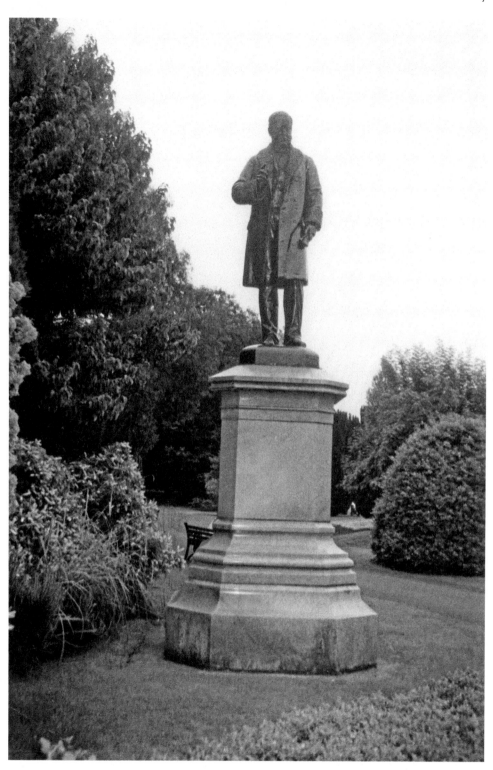

Howell Gwyn's statue.

18

Sherriff of Glamorgan; and served as the Member of Parliament for Brecon and for the Falmouth constituency in Cornwall. He lived at Dyffryn Mansion near Bryncoch and was instrumental in the building of St Matthew's Church, Dyffryn, where he lays buried.

The Gorsedd Stones

These stones are sometimes called Druidic Stones or Bardic Stones. The stone circles are placed in prominent locations to mark the visit of the National Eisteddfod of Wales to the area and used for the Proclamation Ceremony. In Neath's case, they were suitably placed in Victoria Gardens. It does not follow that the Eisteddfod was held in the gardens.

The Eisteddfod has visited Neath on three occasions: in 1918 (when the stones were first placed), in 1934, and again in 1994. The first visit is very significant to those of us who are interested in the town's history. It was at this event that one David Rhys Phillips entered an essay about the history of the area. The essay was in English – the Eisteddfod was a bilingual event then – and David Rhys Phillips won the first prize in the literature category. One of Phillips' friends was Winifred Coombe-Tennant of Cadoxton Lodge; she was a member of the Gorsedd, whose bardic name was Mam O'Nedd. She, together with others, encouraged Phillips to widen the content of the essay and publish it as a book 'befitting a tome for the historian of the Vale'. She used a similar phrase when inviting Phillips to get married from her home.

David Rhys Phillips (1862–1952) was born in Glyn Neath but brought up in Melin Court. After periods spent as a miner and a postman, he was a compositor and proofreader at

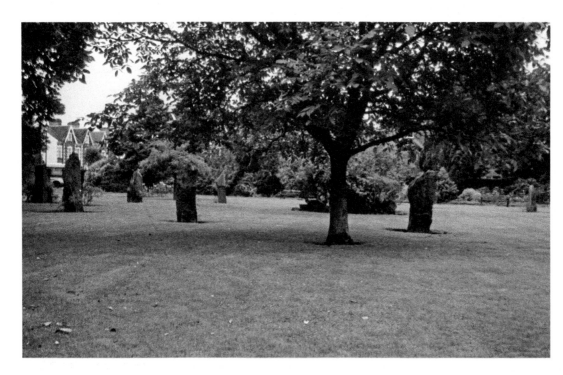

The Gorsedd Stones.

Walter Whittington's printing business in Neath. In 1900, he became a reader at Oxford University Press, and he returned to Swansea in 1905 as Welsh Assistant in the Borough Library. In 1923, he became joint librarian with W. J. Salter. He retired in 1939. He wrote and edited a vast amount of material but locally his name will always be linked with *The History of the Vale of Neath*, which he published in 1925.

When the Eisteddfod came to the area in 1994, Neath Borough Council, together with the West Glamorgan Archive Service, published a facsimile edition of 500 copies, which sold out within days of its publication.

The Drinking Fountain

The 2-meter-high granite drinking fountain is not an original feature of the gardens, but was moved from its previous location in the Old Cattle Market adjacent to Charlesville Place after its demolition in 1956. The fountain originally would have had metal cups attached with chains, which have been lost or removed with time. The original inscription, now worn away, read: 'Drinking Fountain. This memorial was erected by Mrs Rowland of this town, wife of John Rowland, Banker 1863.'

Spanish Civil War Memorial

In 1996, the council placed the granite memorial to three men from Neath who had died while fighting for democracy in the Spanish Civil War. The three men were Harold Davies and Alwyn Skinner from Neath, and James Strangward from Onllwyn in the Dulais Valley.

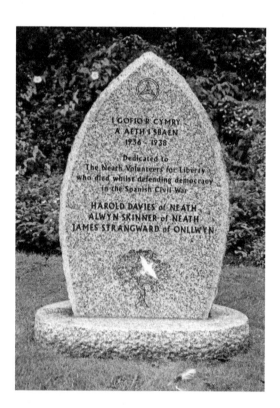

The Spanish Civil War memorial.

The memorial was unveiled by the Spanish poet Marcos Anna, who had suffered under the Franco regime. This war against fascism cost 1 million lives.

The Peacekeeper Rose Bed Plaque
This plaque is set into the ground at the front of the rose bed and commemorates the cessation of hostilities in Japan on 15 August 1945. The plaque inscription reads:

> 'The Peace Keeper Rose' Bed was placed to commemorate the 50th anniversary of the cessation of hostilities in Japan 15/8/45. The rose Bed was planted by His worship the mayor of Neath, Cllr Gareth L. Rowlands and other organisations and individuals of the town of Neath in remembrance.

Victoria Gardens is a designed landscape, listed as Grade II on the Glamorgan Register of Historic Parks and Gardens, and has been appropriately described as a 'quintessential Victorian Urban Park'.

The park was the subject of remedial work in 1991, but in 2008 the local authority secured £1.4 million from the Heritage Lottery Fund for the restoration of the park's original features and the replacement of the old maintenance buildings with a workshop and a community building.

It is the hope that this investment into Victoria Gardens will enable the continuance of the gardens as a place where the population of Neath and the public at large can sit and reflect in a peaceful haven in the centre of a busy town.

4. *Chicago Joe and the Showgirl*

This film, released in 1990 by PolyGram, featured what infamously was known as the 'cleft chin murder'. The victim was the London taxi driver George Heath, who had a cleft chin and was callously shot by the Swedish American GI Karl Gustav Hulten, who had deserted his unit. The showgirl in the film's title was Elizabeth Maud Jones from Neath.

Jones was born Elizabeth Maud Baker on 5 July 1926 and her parents resided at No. 6 Coronation Road. She, it seems, had been a wayward girl, often in trouble with the authorities, and had been imprisoned as far afield at Manchester. When she was sixteen her parents encouraged her to marry Gunner Stanley Jones who was thirteen years older than her, hoping that his maturity would have a settling effect on her behaviour. But the union lasted just one day. She left her husband after he hit her and they didn't see each other again. Gunner Jones was killed at Arnhem on 26 September 1944.

Elizabeth ran off to London, enthused by the glitz of the city (despite the bombings) and a life in show business. She considered her name too parochial and changed it to Georgina Grayson. Following various 'romantic' liaisons and work in clubs as a stripper and a waitress, she clearly considered herself to be working towards a life in show business, relishing the life in London.

Then she met twenty-two-year-old Hulten from Cambridge, Massachusetts. He portrayed himself to her as an officer in the American Army (GIs abounded in all parts of Britain at that time), not telling her that he was a deserter. She seemingly, willingly, accepted the crime spree (which lasted just six days) that Hulten was bent on and followed along on a series of assaults – some fatal, some not. She was complicit in these crimes, not just infatuated, when asking Hulten to steal a fur coat. The association culminated in her facing a murder charge at the Old Bailey.

The eighteen-year-old girl from Neath, together with Hulten, faced Justice Ernest Charles and nine men and three women who formed the jury on 16 January 1945. The trial lasted six days and, throughout, Jones' defence team argued that it was Hulten alone who was guilty of murder. Following its consideration, the foreman uttered one word in respect of both Jones and Hulten: 'Guilty'. The foreman added, in Jones' case, a recommendation of mercy.

The devastating realisation of her wayward ways was brought home to Jones in dramatic fashion when Justice Charles condemned them both to be hanged telling them and those present in the courtroom that they would be buried in a British prison yard.

Hulten, although an American serviceman, could have been court-martialled but the authorities of his country waived its right and allowed him to be tried under English law. He took the verdict without any trace of emotion. Jones, however, uttered a shrill scream: 'The brute, why didn't he tell the truth,' as she was taken down to the cells in tears.

Justice Charles thanked the members of the jury and told them he agreed with their verdict and the recommendation, but under British law the death sentence was mandatory on the English girl. Hulten and Jones had been tried only for the murder of the taxi driver, Heath, and following the sentence the judge added: 'I think you should know that statements of both of them show that these two people have been engaged in murderous and near murderous assaults on other people on these expeditions.'

Immediately following the sentencing, Jones' counsel announced an appeal would be made. The appeal to have the sentence reduced to manslaughter was rejected. Mr and Mrs Baker, Jones' parents, also appealed to the home secretary, which was also rejected.

As eighteen-year-old Jones languished in the condemned cell affording her ample time to reflect on her wayward past, one wonders if she would have thought of her upbringing in Neath. Probably not. Her thoughts would have been on that walk to the scaffold and feeling the hangman's rope around her neck.

However, forty-eight hours before her scheduled execution she was reprieved on account of her age, and her sentence commuted to life. Oral information from that time tell us that graffiti appeared on some walls in Neath saying that she should hang, although I have seen no photographic evidence.

Two days after Jones' reprieve on the morning of 8 March 1945 her partner in murder, Karl Gustav Hulten, left the condemned cell at Pentonville Prison and kept his appointment with Albert Pierrepoint.

A little-known fact is that when convicted killers were sentenced to death (hanging in Britain ceased in 1965) a will had to be made and executors appointed. This also applies to those who are sentenced to life. Thus a hearing was held at Neath Borough Magistrates' Court (located behind the police station on Windsor Road – the site is now owned by Wetherspoons) by Mr W. H. G. Jefferys. The unusual report taken from the *Neath Guardian* in the August of 1945 is carried verbatim:

The Cleft Chin murder case was recalled before Neath Borough Magistrates on Monday, when an application was made by Mr W. H. G. Jefferys for the appointment of an interim curator to manage the property of Mrs Elizabeth Maud Jones who is now serving a term of imprisonment in connection with the crime.

Mr Jefferys said that it was an unusual application and certainly the first time such an application had been made before the court. It was for an interim curator under the provisions of the Forfeiture Act 1870 and related to the property of Mrs Elizabeth Maud Jones, who had been convicted of murder and sentenced to death. The death penalty was subsequently commuted to one of imprisonment, which the girl was now serving at Aylesbury Prison, Buckinghamshire. She usually resided at Neath with her parents, Mr and Mrs Arthur Baker, who still lived at 6, Coronation Road, Neath, and Mrs Baker was the applicant. It was a well a well known principle of law that a person sentenced to death or committed to penal servitude could not deal with his or her own property, and the Forfeiture Act was passed with the object, among others, of enabling property to be dealt with while the sentence was being served. The Act provided that the King could appoint an administrator, or, if no such administrator was appointed, the local justices had the power to appoint an interim curator – a person who they thought was fit to act

as trustee for the conduct of the estate. The application before the court was that the mother should be appointed to the position.

Continuing, Mr Jefferys said that the husband of Mrs Elizabeth Maud Jones was a gunner, who was killed in action at Arnhem on September 26th 1944. He had a certificate of death from the War Office and also confirmation that he left no will. His wife, therefore, was entitled to receive the benefits of his estate but while serving the sentence she could not receive the monies. The War Office had stated that they would release the money if an administrator or curator was appointed. It was known that although the death sentence was commuted to life imprisonment she would not serve that time, but would be released from her present position, and even if that were not so, could receive some little extra comforts in her place of confinement.

Nellie Baker, 6 Coronation Road produced the certificate that her daughter's husband was presumed killed in action while serving in Western Europe, and a letter from her daughter that she approved of her holding the post of curator. She proposed investing the money for her daughter's use. Her daughter had just turned 21.

Arthur Baker, the father, said that he approved of his wife being appointed.

The Mayor, Councillor Philip Howells, who presided, said that the Bench had decided to grant the application, but wanted to warn Mrs Baker very seriously of her great responsibility. 'You will have to keep the money intact: otherwise you will be in trouble yourself', he said.

Dalton Road, formerly named Coronation Road.

From the *Neath Guardian* report, it seems that two years had elapsed before her mother was appointed curator to her daughter's estate. Elizabeth served a term of nine years and was released in 1954; it is said she returned to Neath and led and exemplary life. It is believed she died sometime in the 1980s.

Interest in the case has continued. In 1948 the film starring Diana Dors, *Good Time Girl*, was released by J. Arthur Rank, written and directed by Sydney Box, which followed the story of the Cleft Chin Murder. Elizabeth Jones' parents and the Member of Parliament for Neath, D. J. Williams, protested that the film was trading on the Neath girl's downfall. Their attempt at censoring the film was unsuccessful. In 1990, *Chicago Joe and the Showgirl* was released starring Emily Lloyd and Kiefer Sutherland.

5. The Lady Pirates of Briton Ferry

Not quite the desperate cut-throats of the high seas, but nevertheless a story about matriarchs from Briton Ferry who ran the gauntlet of the customs men as they brought illicit goods from the ports and towns along the Bristol Channel up the River Neath, with the gentry complicit in their activities by providing the hiding places made available to them by clergy and no less a name than Mackworth of the Gnoll. Locally we dramatise these activities with the word 'pirate'; they were smugglers, but undoubtedly with a sharp edge.

The period around the early 1700s saw Catherine Loyd, Catherin Morgan, Elizabeth Chandler and Mary Shaw ply their trade along the coast, constantly watchful of the customs that men continuously pursued. This group of ladies smuggled tea, whiskey, brandy, wine and a variety of goods that could be sold on in the town, and seemed to fall foul of the government officials only on one occasion.

Catherine Loyd, landlady of the Ferry Inn and leader of the smuggling gang, let her guard slip when she offered contraband goods to one Edward Dalton from Llanelli who had called at the inn to refresh himself. Not realising he was an officer – probably a customs official – she was prosecuted. It seems to have been the only time this resourceful lady paid the price for her infamous activities. As David Rhys Phillips records in his tome *The History of the Vale of Neath*, whether this prosecution curtailed her illicit career on the waters of the Bristol Channel is not known.

Not that the gentry of the town escaped the shroud of suspicion: the officers of the law raided the mansion of Sir Humphrey Mackworth. A raid on the property of this pillar of society wouldn't have been embarked upon lightly, but there is no record of him being prosecuted. And the raids made on gentry houses would often end with assaults on revenue officers, accompanied by a riot.

Assaults and violent behaviour were clearly not restricted to those harbouring the illicit tea and tobacco. We have recorded that one of Catherine Loyd's shipmates, Mary Shaw, roughed up a customs officer when he tried to seize goods. It transpired that he had no authority to carry out his work on that occasion, thus the ladies of the salt retained their possessions, and Mary wasn't prosecuted for assault either. The ports of Neath and Briton Ferry and the wharf at Neath Abbey all saw exciting times when the ladies of the Ferry docked their ships on the River Neath.

The activities of Catherine Loyd and her friends are dated c. 1726, and then we have another bevy of Amazons operating from the same port around the 1760s. Whether these ladies – Luce James, Ann Tibbs, Grace Morgan and Rachel Howell – were in any way related to the smuggling dames of earlier years isn't recorded, but they were equally (if not more) resourceful than the ones that went before them. They, too, smuggled tea, tobacco, etc., but were never apprehended by the authorities, although there were occasions

when they relied on men on the portside to protect their goods and honour. On one such confrontation at the wharf in Neath Abbey, a group tying the ship were complicit with the ladies by throwing a customs man into the river. The ladies made a getaway. These were colourful times on the river drawn by the strong, determined women of Briton Ferry.

As an aside to the smugglers, when helping James Rees of the Castle Hotel to write a brief history of the building, we came upon a bricked-up entrance in the cellar. This, we believe, blocked a tunnel that would have led to the edge of the river. Would this have been a route used by the smuggling fraternity to facilitate an access into the town via the Castle Hotel? We'll never know, but it has romantic overtones. Coupled with this tunnel is a ghost story, too. There are tales of the ghost of a hound that howls; those who have heard it tell of a terrifying sound.

6. Bert Coombes:
Neath's Bestselling Writer

Bert Coombes' weekly articles used to light up the pages of the *Neath Guardian*, detailing his observations from his work in the colliery to the visits to the Neath Fair and everything that caught his attention and imagination. These articles were my introduction to his work and were always headed 'B. L. Coombes Miner Author'. As a child I asked my father about him, who worked in Fire Engine Pit in Bryncoch, Brynteg in the Dulais Valley, Cefn Coed and the Darren, Trebanos for forty-four years: 'Always turn to his stories first when the paper comes,' he said. 'He's a collier and a writer. Read the bestselling *These Poor Hands* and his book *Miner's Day*, these books carry the best descriptions of a coal miners' life.'

Bert Coombes was born in Wolverhampton on 12 January 1893. A few years after his birth the family moved to Treharris, his father finding work in the colliery. Another move followed and in 1906 his family had taken the tenancy of a farm in Madley, Herefordshire, this is where Bert spent his informative years.

Leaving school at fourteen, he worked as a farm labourer and then as a groom to the local vicar. Although he claimed he enjoyed the work to a certain degree, he knew it couldn't sustain him.

Expressing these thoughts with friends at the vicarage, suggestions followed where one said I have a relative in Ammanford, you'll find work there; someone else mentioned the Rhondda Valley and another knew someone in the Vale of Neath.

He wrote the three locations on three separate pieces of paper, rolled them up and placed them in a hat and felt for one piece and brought it out: it said the Vale of Neath. And thus Bert left home and made his way to Cwmgwrach.

He found work immediately and then settled in Resolven where he married the union man's daughter Mary Rogers in 1913 and set up home in 10 New Inn Place. They had two children, Rose born in 1914 and Peter in 1924.

Coombes clearly had a restless mind and during strikes and stoppages in the colliery he set up or joined organisations such as the Resolven branch of St John Ambulance; Resolven Cricket Club; and playing and making musical instruments. When he was in his early forties he started to write; he realised that the world outside of the mining industry knew little about the dangers of working underground and he started to submit articles and stories to publishers about the miners' lot.

As with all aspirant writers, the rejection slips accumulated, but he caught the eye of the editor of *New Writing*, John Lehmann, who published a story called *The Flame*.

By the late 1930s he had moved his family to Oak Lodge in Resolven and worked, writing every night after his shift in the colliery, on a longer autobiographical story that was picked up by the left-wing publisher *Golanz* and titled *These Poor Hands*, which

Bert Coombes and his son Peter in 1941.

was published in 1939 and became an international bestseller. The book was reviewed by *Picture Post*, an internationally published literary magazine that brought the name of B. L. Coombes to a worldwide audience. Despite this success and the fruits it bore him, he refused to cease his employment underground.

His book *Miners Day* is a sterling work that graphically set out – as the title suggests – a life in a coal miner's day. Considering that hardly any deep mining takes place in Wales now, it should be statutory volume for students who study our industrial and social history.

From the 1960s he contributed weekly articles to the *Neath Guardian* (always unpaid), which brought his writing on a wider range of his interest to a different audience outside the coal-mining industry, albeit in Neath and its environs, which made compulsive reading.

DID YOU KNOW?

Bert Coombes was self-educated, mastering the techniques of grammar and composition through usage. His work is the authentic story of coal mining from a miner's perspective and not a romantic, mawkish ideal that is sometimes published.

His love of country living would never have left him, and when the opportunity to occupy Nant-y-Fedwen on the road between Banwen and Coelbren presented itself, he took it, and spent the rest of his days there.

His wife Mary died in 1971 after fifty-six years of marriage and he passed away three years later, in 1974, at the Adelina Patti Hospital and was buried with Mary in St David's New Cemetery at her home village of Resolven. The grave is marked by their names and dates of death and the text under Bert's name simply says, 'Author'.

The chance of lottery brought him to Neath and for that we should ever be thankful.

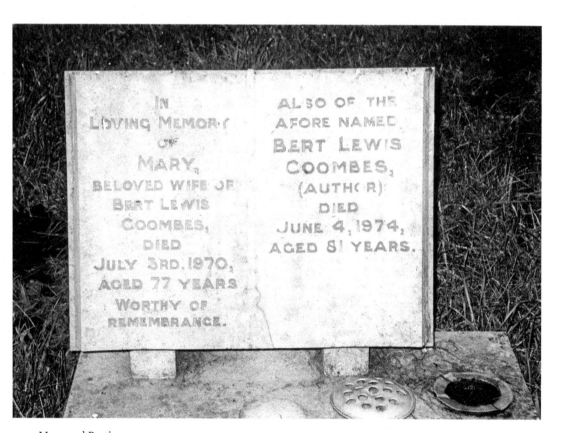

Mary and Bert's grave.

New Inn Place.

7. Harry Parr Davies: Neath's Forgotten Composer

Harry was born in Grandison Street, Briton Ferry, on 24 May 1914, the son of a cobbler. He was essentially a self-taught musician who showed an early flair for music composition and lyric writing. Soon after his birth his family moved to Arthur Street in Neath. He attended Gnoll School and the Neath County School. During his early youth he was an assistant/deputy borough organist. He had already started to make his mark with his compositions as a fourteen-year-old; a concert held in Wesley Church, Neath, featured songs from his musical *The Curfew*.

Bespectacled Harry Parr Davies seems to have been a shy person; there is little record of any romantic involvement throughout his short life (he lived forty-one years) but his musical composition and his gift for lyric writing was prodigious. Despite his shyness, he did write to the famous Sir Walford Davies, enclosing copies of some of his work together with a letter that asked for advice regarding publishing his work. Davies quickly realised that he had received a plea for help from a gifted musician and writer and directed him to the London musical scene and put him in touch with publishers who could assist him.

By the age of seventeen (in 1931) he had received a royalty advance from a publisher for £1,000; it is said to have been the highest figure paid to a composer up to that date anywhere in the world.

Despite his shyness, Harry had made an early mark. Still just seventeen, he boarded a train from Neath, bent on meeting Gracie Fields to show her some of his music and lyrics. It is said that he knocked on a side door of the Winter Garden theatre in Drury Lane, London, and was admitted because the door attendant thought he was the post boy. He found her dressing room and knocked the door. What Miss Fields thought when she saw him isn't recorded, but she was clearly of a very good nature because she listened to him and read his work. Like others before her she realised his genius, and soon after he became her sole accompanist (piano) and she mostly recorded his compositions.

The biographical film of the life of Gracie Fields makes constant reference to Harry, where she sometimes said, 'My Harry'. Singing and acting stars' names are likely to remain famous (at best) or at least well known, but composers' names often drift into obscurity. Such is the case with Harry, but throughout the 1930s he worked with Gracie Fields, Jack Bucchanan and Anna Neagle to name but three singing stars who are still remembered today.

Harry's 'Wish Me Well (As You Wave Me Goodbye)' was an outstanding hit for Gracie Fields and a wartime favourite. It is still heard today in recordings of the comedy *Dad's Army*.

During his informative years he claimed that his mentor was Mr Seymor Perrott, the Neath Borough organist. I know nothing of Seymor Perrett, but as Harry's fame grew he claimed that 'this man is responsible for everything I have achieved'.

His association with Gracie Fields was a halcyon period in his life and development. She would have no other accompanying her, and he travelled the world.

In 1939, he joined the army and was soon seconded to ENSA, writing musicals, songs and plays with which to entertain the troops. There is an endless list of songs but some of his best known are:

'Wish Me Well (As You Wave Me Goodbye)', 'Pedro the Fisherman', 'Sing As You Go', 'Crash Bang, I Want To Go Home'.

Of his musicals, the best known is *Black Velvet*, which was a commercial blockbuster in 1943 and played the London Hippodrome for 620 continuous performances. In fact, it only ceased because the government closed most of the halls and places of entertainment during the bombing.

Some of his other well-known musicals include *Lilacs In The Sun, Looking On The Bright Side Of Life, Look Up And Laugh, The Show Goes On, Shipyard Sally, Crash, Bang, I Want To Go Home, The History Boys* and *The Lisbon Story*. The latter had its premiere in Neath at the Gnoll Hall and was performed by Neath Amateurs, a society that was founded in 1911. This showing was, naturally, packed, and Harry returned to Neath to see the performance.

Of those he worked with and who performed his work is a list of greats who many of us will have admired and, of course, repeated their songs: Gracie Fields, Betty Driver (better known as Betty Turpin in Coronation Street), Evelyn Laye, Geraldo, Michael Wilding, Pat Kirkwood, George Formby, Flannagan & Allan, Anna Neagle, Richard Murdoch, Jack

Arthur Street.

Buchanan, Tommy Trinder and Tessie O'Shea (Harry is the author of her greatest hit 'Keep Smiling').

His success continued unabated after the war years and he lived in London. His work pops up in some unusual places – Monty Python even performed a parody of one of his songs. He died on 14 October 1954, only forty-one years of age, after developing a perforated ulcer and because of a paranoia regarding doctors he didn't seek assistance. He was at the height of his powers at the time.

He is buried in Oystermouth Cemetery in Mumbles, Swansea. He is commemorated in Neath by a plaque in the Old Town Hall on Church Place and a street named after him called Parr Avenue.

Harry is to Neath what the more well-known Ivor Novello is to Cardiff. Some years ago, while taking a group on a historical tour, I stopped outside the house in Arthur Street where he had lived. The owner of the house came out and asked what we were doing. I explained that Harry had lived there. She didn't know, but she was delighted.

8. Wall Panels on Church Lane: Rubin Eynon

The unusual wall panels, or roundels, set on the rear walls of the shops on Wind Street are the work of the artist Rubin Eynon, who was living in the Vale of Neath. Rubin is the son of the well-known artist Christine Eynon.

The panels are cast in Jesmonite resin and are the result of a project that Rubin led with a group of teenagers from a local youth club. Rubin explained that the teenagers designed the larger roundels, which he then modelled in clay and cast in resin. The smaller flower roundels are based on window designs in St Thomas' Church. The overall shape of the panels, with the gears, depicts the industrial heritage of the Neath area.

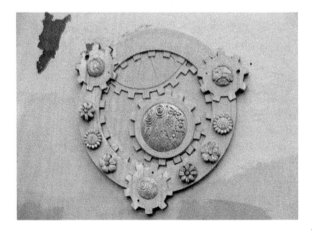

Wall panels on Church Lane

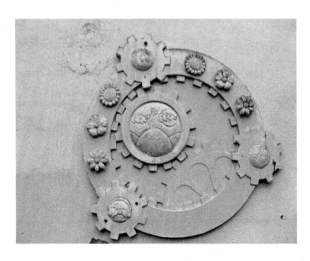

9. St Margaret's Chapel and Well

The remains of this obscure chapel is to be found by driving to the end of School Road in Jersey Marine and by seeking permission from the landowner in the bungalow to the right of the gate at the end of the road. All that is to be seen are a few walls, some of which were rebuilt. The area was cleared by antiquarians in the 1930s/1940s.

A reference from *c.* 1200 tells us: 'the fishing of Sub Pulcanan – Pwll Cynon – which Ranulph the Hermit formally held'. Arguably a hermit of that name perhaps could have formed a cell on the site. The first actual record is dated 1289 when the Earl of Gloucester, Gilbert de Clare, assigned lands to the Abbot of Neath Abbey: 'Under the mountain of Coit Franck to opposite the Chapel of St Margaret's, in length under the chapel as the moor divides wet and dry ' The description is accurate because the location is on the edge of Crumlyn Bog. But the statement indicates that the chapel was in existence before that date.

In 1504, the late incumbent at Newton Nottage, Porthcawl, Reverend David Williams, bequeathed 'two shillings [ten pence] to the fabric of the Chapel of St Margaret of Coed-ffranke'.

The chapel remains something of an enigma in respect of what it was actually used for. It could have been a chapel of ease providing sucker for wayfarers or pilgrims going to or returning from St David's. Those inhabiting the chapel would probably have been familiar with the treacherous terrain of the bog and knew the route through it.

Three skeletons, one complete and two partial, were found during excavations in the 1900s and discovered to have been females. Two were reinterred and the third was retained for analysis, which indicates that it could have been a nunnery connected to the monastery of Neath. The dedication is to Margaret of Antioch, as she is known in the West; Eastern tradition call her Marina. Churches dedicated to her were popularised following the crusades. Upwards of 200 churches are named after her, none less so than St Margaret's Church at Westminster.

Her Feast Day is 17 July, which correlates with the Charter of the Neath Fair – held on this date. Apart from St Margaret's Chapel in Jersey Marine, we also have an Anglican church in Crynant named St Margaret's. St Margaret's Well is said to have been in a lee in

DID YOU KNOW?

The ruins are a scheduled Ancient Monument and work was carried out there by Glamorgan-Gwent Archaeological Trust and the University of Leeds.

the land below the chapel and its waters were reputed to have healing powers if drank or washed in.

It isn't recorded when the site became uninhabited but quite likely some of the stone was taken to be used in the building of Panisycoed, a farm on the land, in the nineteenth century.

Some years ago I took a group of Catholics to the site, led by Father Christ Fuse of St Joseph's Church in Neath, who said prayers and blessed the area. This was possibly the only time a priest had carried out this rite since the original occupants of the site had left.

10. Neath and the Castle Hotel

The surrounding areas of Neath have a far older history of human activity than Neath town. Bronze-Age burial chambers and Iron-Age hill forts are to be found on the upland hills and the Romans constructed a fort at what is now called Roman Way in around AD 70.

The history of the actual area that Neath town occupies today commences in the early twelfth century with the Norman Conquest of Glamorgan. Sir Richard de Granville defeated the local Welsh lords and established, according to Neath historian, the late George Eaton, a timber motte-and-bailey castle near Court Herbert in 1129. This was later destroyed by the native Welsh lords. The monastery at Neath Abbey was founded by charter in 1142 and, also by charter (celebrating St Margaret's Day), the Neath Fair was established. The fair still runs today and is arguably older than the famous Nottingham Goose Fair.

A second castle was erected on the east bank of the River Neath – the site of the present castle. A small village with a market and a church was developed by the Normans around 1150. This later formed the nucleus of Neath town. Intermittent warfare between the Welsh and the Normans continued for the next 150 years and so hindered any development and population increase. The town of Neath was destroyed by the Lords of Afan in 1184, 1230, 1259. Peaceful conditions from the fourteenth century onwards allowed the village to develop and for commerce to expand. A river bridge was erected in 1320, and trade flourished and regular markets were held.

The Tudor period saw the demise of the Marcher lordships and the emergence of the gentry class of people, who assumed control of trade and economic growth with a portreeve and a body of councillors to govern the town. Coal mining commenced around Neath in the early sixteenth century, and copper smelting in the surrounding area at Aberdulais in 1584. Neath was still a small town clustered around its castle and church throughout the fifteenth and sixteenth centuries but huge changes were to take place in the seventeenth and eighteenth centuries.

The Evans family of Eaglesbush expanded the small coalfield at the lower Cimla, which were greatly improved and enlarged by the Mackworth family from Derbyshire. The Mackworths constructed one of the largest and most modern copper-smelting factories in the country at Melincryddan in 1695. The refined pigs of copper were transported to the Gnoll mills, where they went through a number of processes of battering, rolling and eventual manufacturing into pots and pans. Neath became an industrialised town at that time with coal mining and heavy metal refining as a major source of employment. The streets of old Neath remind visitors of the pre-industrial nature of the town – Cow lane, Duck Street, Cattle Street, Butter Street, Bull Ring – some of which survive to the present time.

Cattle Street.

The Neath Canal was completed from Neath to Glyn-Neath in 1795 followed by the Tennant Canal in 1825 from Aberdulais to Swansea by George Tennant of Cadoxton Lodge. These led to an increase in manufacturing industry reliant on coal as a fuel. Brick making, ship building and chemical production on the town's outskirts and iron manufacturing at Neath Abbey. In 1823, Neath's population was only 3,000 persons, which increased to 4,000 by 1849 and to 14,000 in 1880.

The arrival of the steam railways was a major factor in the expansion of industry and population growth. The Great Western Railway 1850 and the Vale of Neath Railway 1861 encouraged industrial growth. An industrial suburb was created at Melincryddan due to the construction of the Melyn forge and foundry 1864, the Melyn tinplate works 1864, Eaglesbush tinplate works 1890 and later the Neath Steel Sheet and Galvanizing Co. works adjacent 1896.

Neath also became a prosperous commercial centre and fine civic buildings were erected: the Old Town Hall in 1820, the new market in 1837, the Mechanics' Institute in 1847 (where Alfred Russell Wallace worked on his ideas on the evolution of man), Alderman Davies' School in 1858, St David's Church in 1866, the Gwyn Hall in 1887 and Victoria Gardens in 1897. New streets were laid out too – Windsor Road, London Road, Queen Street, Eastland Road, Cimla Road – and residential suburbs sprang up at Penydre, Tyn-y-Caeau, Mount Pleasant and Hillside.

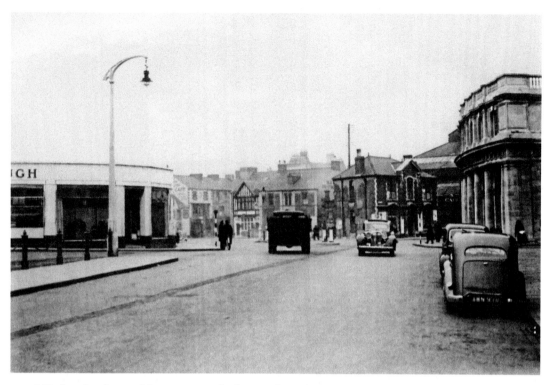

Windsor Road, one of the new streets laid out at the end of the nineteenth century.

Following the 1945 election, a policy of public works was established, one of which was a vast programme of local authority house building. Westernmoor, Longford, Caerwern, Tonna, Caerwathen and Briton Ferry, together with the valley areas, all benefitted from the provision of suitable housing. Neath is a pleasant town to shop in; it has many attractions for the visitors and locals alike. The Victoria Gardens is a Victorian gem where one can relax away from the bustle of shopping. Neath Museum, which occupied part of the Gwyn Hall, houses displays that depict the area's history. The Gnoll Country Park, once the seat of the Mackworths, is now a magnificent country park. Neath Canal, which at one time was the lifeline of industry, has been tuned into a linear park that offers boat trips in the summer months.

Neath is a historic town that retains much of its former character and charm and also its culture. Operatic societies and musical entertainment are frequently hosted at the Gwyn Hall and similar venues in the town. Neath is a town for all ages and interests and well worthy of visiting.

Occupying a prominent position in Neath, both in a geographical sense and a historical one, the Castle Hotel has been a focal point as a meeting place and a licensed premises for more than 400 years, thus making it one of the oldest – if not the oldest – drinking establishments in the town.

Hostelries and ale houses (it's difficult to categorise them separately, save for the fact that the former would have offered accommodation and the latter were simply drinking houses)

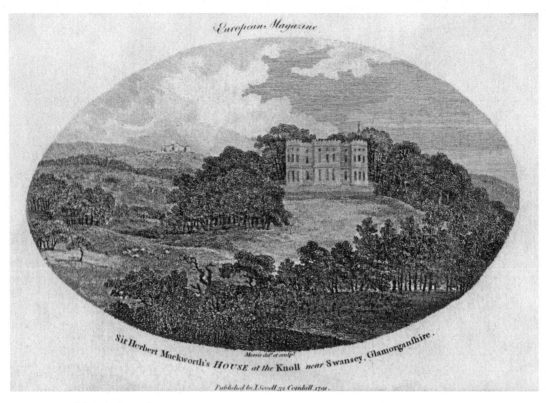

European Magazine

Sir Herbert Mackworth's *HOUSE at the* Knoll *near* Swansey, Glamorganshire.

Morris del.' et sculp!

Published by J.Sewell 32 Cornhill 1791.

Home of the Mackworths.

would not have required a licence as we understand the procedure today, and they usually traded under the proprietor's or the landlord's name. One of the first references to the Castle Hotel was when Sir Edward Mansel of Margam Abbey made a visit to Melyncryddan Works in 1699 where 'he dined in great company at 'Proffs'. By 1758, the hotel had been bestowed with the name of the Ship & Castle, a receipt found in the building and dated 1 January 1758 for £2 7s 6d issued to Lewis Davies of the Ship & Castle for a wine licence.

In 1784, the Gnoll Masonic Lodge, now located in Queen Street, moved to the hotel. The landlord at that time was William Merrick, a member of the organisation.

In 1788, the Castle, now usually referenced as an inn, was taken over by Charles Nott, father of Major-General Sir William Nott GCB, who led the charge of the defence of Kandahar in 1842. He also served with Lord Nelson on HM *Victory* at the Battle of Trafalgar. It is believed that Sir William was born in the Castle, which makes him certainly the most famous person to have started life from the building. His father, Charles, moved to a public house in Carmarthen when William was four years of age. There is a statue of Sir William Nott standing overlooking the square in that town.

During the nineteenth century, the Castle was called the Ship & Castle and was one of the most important coaching inns and stopping places for Royal Mail coaches en route to and from London to Milford (calling at Bristol) and Pembroke to Gloucester. Coach horses would be changed here and on occasions the inn was a night-time stop over.

Thus the case when Lord Nelson and Lady Hamilton spent a night in the building while travelling to Bristol. History records for us that Nelson was short of stature and he needed a set of steps to climb into his bed – those steps are still in the Hotel to this day and the Tudor-styled canopy bed that Nelson and his Lady slept in is still in use in the Tudor Room. The cobbled entrance to the stable area is still in evidence today, located off New Street and the giddying stones are still in place at the back of the hotel.

There are various references to the Ship & Castle recorded in David Rhys Phillips' *History of the Vale of Neath* to HM Customs and Excise using the building for various reasons: 'the Ship being the area's principle inn'.

There have been many 'sales' conducted at the hotel and one of the most interesting is that of the property sold here in the mid-nineteenth century belonging to David Thomas, manager of the Ynyscedwyn ironworks in the Swansea Valley.

David Thomas was born at Tyllwyd Farm, Bryncoch, on 3 November 1794. He was the only son of David and Jane Thomas, who also had three daughters. The young David was schooled in Alltwen, Pontardawe, and then at the acclaimed Neath Academy. Unusually for this period, Thomas was literate in both the Welsh and the English languages. On completion of his primary education he worked with his father on his small farm. In 1812, he took up employment at the Neath Abbey Iron Co. and was placed under the tutelage of the company's chief engineer, Henry Taylor, who very soon recognised the qualities and intellect of the eighteen-year-old Thomas. During his term of apprenticeship he sent him to Cornwall to oversee the installation of a blowing engine.

Thomas worked at the Neath Abbey works until 1817, leaving there to take up employment under Mr Richard Parsons at Ynyscedwyn Iron Co. in the Upper Swansea Valley. Soon after taking up this employment, Parsons went bankrupt and Mr George Crane, a Bromsgrove nail-maker, was brought in to manage the works by the creditors. Thomas was still only twenty-three years old and stayed at Ynyscedwyn for twenty-two years. During that time, he found fame in the iron trade by successfully converting a furnace to anthracite coal and blowing the furnace with hot air. Previously, the method used was with dirty bituminous coal. The new method was quicker, cleaner and produced a better product. The furnace was successfully blown early in February 1837.

The idea that hot blast could work was realised in 1828 by Beaumont Neilson of Glasgow following a seemingly unimportant event it is said took place in Mr Crane's house, located near the Ynyscedwyn works, when he was talking with Mr Crane and was told to use the blower to encourage the fire in the grate to spark up. Thomas did his bidding and said: 'If this blower was pumping hot air the anthracite coal would burn like pinewood.'

Considering this comment and the Neilson idea, which had been patented, Crane sent Thomas to Scotland to learn more about it. He returned to south Wales with a licence to take the idea forward. Neilson's idea was to use coke blasted by hot air; Thomas thought that the idea would work equally well, if not better, with anthracite coal. History tells us that he was right.

Thomas' development of hot blast was brought to the attention of industrialists in North America when the method was published in a scientific magazine, the *London Mining Journal*, in 1838. Mr Erskine Hazard, one of the directors of the Lehigh Coal & Navigation Co. in Pennsylvania, travelled to Ynyscedwyn to see the hot blast system's operation. Mr Hazard

was taken to meet David Thomas, who had moved to Defynog to supervise the building of the Brecon Forest Tram road link to the Ynyscedwyn works. In America, the system of hot blast had failed but on seeing it working under Thomas' stewardship, a five-year contract was offered to David to go across the Atlantic to develop the method there.

Undoubtedly, Thomas was faced with a dilemma. He was married with four children and was forty-three years of age. At Ynyscedwyn, he held a post of responsibility as the superintendent of the works, which included Banwen Iron Works, and was relatively well-off financially. He owned property and had clearly exercised his fiscal affairs efficiently. Whether he was seen to waver at the offer of a five-year contract or whether it was only for him to travel isn't known but Mr Hazard then offered to ship Thomas and his entire family across the Atlantic. This was clearly an attractive offer, and he signed a contract on 31 December 1838 to build furnaces in the Lehigh Valley that would be fired by anthracite coal. Certainly Thomas' character was clearly of a direct and determined nature. He only possessed a contract for a five-year period, yet in the early months of 1839 he put all his property (he owned between five and eight cottages) up for auction at the Castle Hotel, Neath; and the fact that his wife, Elizabeth, was a monoglot Welsh speaker couldn't have had a bearing on his decision. In May of 1839, he travelled with his wife, three sons and two daughters from Swansea along the coast of west and north Wales to Liverpool, where they boarded the *Roscius* at Waterloo Dock and set sail for a new life.

So, arguably, Thomas' last item of business was conducted at the hotel. Today, Thomas isn't known by most of Neath's residents. His parents are buried in Maes-yr-Haf Chapel's graveyard. Once he settled in America, he became one of the most important industrialists there and is referred to as the 'Father of the Iron Trade'. When he died, a eulogy recorded that he had made more of a contribution to the industrial, spiritual and social life of that country than any man before him.

DID YOU KNOW?

Isambard Kingdom Brunel stayed at the Castle Hotel in the late 1840s while overseeing the building of the Neath to Swansea sections of the Great Western Railway, which included the Neath Abbey viaduct and the steep Skewen incline.

The inaugural meeting of the Welsh Rugby Union was held in the Castle Hotel in 1889 and the crests of the original clubs are displayed in the Centenary Room. A meeting of the directors of the union was held in the hotel to mark its centenary. A plaque commemorating the event is on the front door of the main entrance.

One of the most well-known local characters to have worked in the hotel during recent years is the former manager, Mr Darryl Jeremiah. Darryl's employer was Evan Evans, the owner of the Vale of Neath Brewery, which was in Cadoxton. When Evan Evans bought the brewery in 1850 following the failure of the business, he developed the ale-making

process and also had the foresight to make sure he had outlets for his products. To satisfy this he embarked on buying up many drinking establishments in south Wales, mostly in Neath, to ensure that he had regular customers for the beer made in Cadoxton. One of the properties he bought was the Castle Hotel, which became a flagship establishment for both him and later his son-in-law, David Bevan, who became known as David Evans-Bevan and later as Sir David Evans-Bevan, the 1st Baronet of Cadoxton Juxta, Neath. This title passed to his son, Sir Martyn Evans-Bevan, who resided at Margan Abbey. So Darryl had an esteemed employer and rose from a being a pageboy to being appointed general manager.

Darryl can enthral for hours about his time at the hotel. Names like Richard Burton, Elizabeth Taylor, Ray Milland, Harry Parr Davies, and dozens of television soap stars have spent time here enjoying the hospitality of both Darryl and the hotel.

Currently, the castle is home to the Showmen's Guild of Great Britain, Rotary Club International, Scroptamists International and the Neath Chamber of Trade. On Boxing Day, the Banwen Miners' Hunt holds its traditional meet from the hotel. This attracts hundreds of followers and the parade outside the hotel is full of horses. A very colourful sight, the Green Bar on that morning is absolutely packed. This meet has been held since 1962 when the hunt was formed.

Around 1845, Captain Frederick Fredericks of Duffryn, Bryncoch, could fire a revolver through a mirror without breaking the glass, except for the perfect hole made by the bullet. A wager was struck with the captain, who duly won the bet. The mirror was originally hanging in the hotel's Nelson Bar but was unfortunately lost during a refurbishment.

Considering the length of time the hotel has been trading, it has a significant amount of social change, much of it discussed and instigated within the building. The stories of hauntings, ghosts and spirits abound, a selection of which follows shortly.

The most prominent hostelry in the town, and one of the oldest, is the Castle Hotel, dominating the Parade with an air of well-kept elegance. It is the place where most of the visiting celebrities and VIPs will stay. At various periods in its history it has been known as the Ship & Castle Inn, the Castle Inn and now, of course, the Castle Hotel. It is, too, arguably the town's most haunted building.

Early records tell us that the Castle Inn (arguably the town's most haunted building) was built in 1695, but remained unnamed and traded under the landlord's name – 'Proffs'. It has been the focus for many events, important meetings, seminars, etc. In 1699, Sir Edward Mansel dined there after visiting the Melyncrythan Works. In 1784, the Gnoll Masonic Lodge was 'removed to the Ship and Castle Inn', the landlord then was William Meyrick, who was also a mason. In 1786, Charles Nott, the father of Major-General Sir William Nott, became its landlord; Sir William Nott's birth date coincides with his father's tenure of the inn. Charles Nott left Neath in 1796 for the Ivy Bush in Carmarthen.

In 1796, Lewis Roterley took over the management of the inn, but he left after just four years for the Mackworth Arms in Swansea. Like his predecessor, he had a prominent son: Major Lewis Roterley was Lieutenant of Marines on the *Cleopatra* at Martinique in 1808.

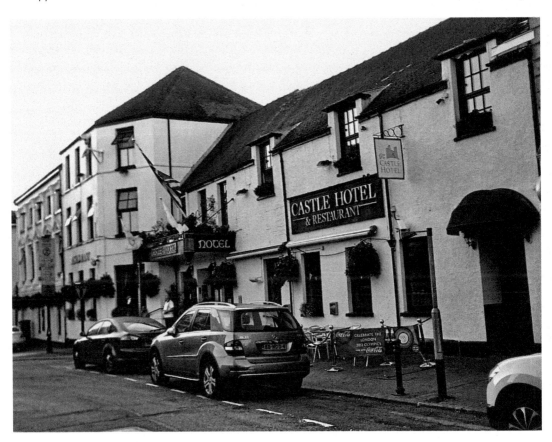

The Castle Hotel.

From 1789, the trustees of the Neath Turnpike Trust held their meetings at the inn, and the auction for the letting of the toll gates was also held there. From 1792 until 1808, it was the venue of the committee briefed with the rebuilding of the Neath River Bridge. Lord Nelson and Lady Hamilton are said to have frequented the inn on a number of occasions and, in more recent times, Richard Burton and Elizabeth Taylor were guests. Indeed, it was in the Nelson Room in 1881 that the Welsh Rugby Union was formed.

The current proprietor's son, Mr James Rees, has recorded several strange happenings following discussion with Mr Darrel Jeremiah, a former general manager of the Castle Hotel.

The Chamber Maid

Sometime in 1845, a chambermaid hanged herself from a ceiling rose in the hotel's old wing. In 2003, an investigation was carried out in the hotel by Mr Gifford's Psychic Fare, and a medium revealed the following: The young girl was around seventeen years of age and working in the service of the Bloods of Neath, who owned the business at that time. The psychic described an image of the girl leaning out of the window that backed on to what is now New Street, looking at her lover who was on horseback, dressed in hunting pink. She is heavily pregnant with his child.

Convention in society at that time dictated that it wasn't acceptable for a gentleman of her lover's status to marry the lowly bred chambermaid, expecting a child or not. Thus, considering her condition, she was desperate and her mind would have been in turmoil. Clearly she accepts the situation she has found herself in.

The lover rides off to enjoy his day's hunting, leaving behind (and possibly unaware, but I doubt that) of her emotional state. Had she accepted that their love or any concern for the unborn child could entice the huntsman to marry her?

Faced with the prospect of bringing up a child out of wedlock and fearing the scorn with which she will be treated she hangs herself from the ceiling and slowly strangles.

This poor girl has been seen leaning out of the window in a distressed state, probably pleading with the horseman to have consideration for her.

It wasn't known to the medium that the stable yard being described is now the back of shops on New Street.

The Old Ball Room
Following a paranormal research investigation in 2005, the presence of an old man and several orbs were detected in this room. Through the medium the old man revealed that he was a stable hand. The Old Ball Room was built over the hotel's sold stable block. This information was not known to the investigation team at that time.

Room 16
This room is said to be haunted by a woman who burnt to death there sometime during the early 1800s. Members of the hotel's housekeeping staff have fled, screaming from the room after hearing loud thudding noises. A previous housekeeper said that if the staff rearranged items of furniture in the room the ghost of the woman would become angry and cause objects to suddenly move.

Rooms 14 and 15
In the corridor outside rooms 14 and 15, a young girl has been seen on various occasions, apparently floating up into the wall. Following the examination of a set of old structural plans of the hotel it was discovered that at the point where the girl was seen and then strangely disappears, there was once a staircase leading up to the servants' quarters.

Upon investigation of these hidden rooms, it was found that they had been gutted by fire, possibly the fire that cut through the building in the 1800s. It appears that a decision was made to seal up these servants' rooms and remove the staircase. Could it be the haunting of the chambermaid who tragically hanged herself making her way to the safety of her room?

Lady in a White Robe
Over the years many members of staff have reported seeing a red-haired woman, dressed in a flowing white robe (or is it a shroud?) in the corridor outside rooms 25 and 26. Little is known about her, although her presence has always left those members of staff who have seen her feeling uneasy and saddened rather that frightened.

Room 4

This is now used as a guest room but was once, many years ago, used as a residence by the then owners of the business. This room does seem to have uneasiness about it. Those who have experienced it say that objects have been known to fall from shelves and shatter for no apparent reason.

Two residents who had been booked into this room reported to the manager the following morning the various disturbances that they had experienced. They both felt a weight at the bottom of the bed reminiscent of someone sitting on the end of it. They eventually fell asleep only to be woken up by a banging noise that came from somewhere in the room, but strangely they couldn't pinpoint exactly where. 'It seemed to be everywhere, all around us,' they vaguely reported, 'but it lasted throughout the night.' Not surprisingly they requested to be allocated another room for the duration of their stay in Neath.

Christmas Eve Haunting

Christmas Eve is one of the most evocative nights in the calendar. On this date in 1998, the deputy manager and one member of the staff were sitting in the foyer. All the guests had left, the hotel was closed, and all the lights were off save for the one in the foyer. Christmas Day, then, was a rare day off. The hotel had been checked to make sure that no one was on the premises; the hotel was empty and the heavy silence that fills such usually busy buildings had settled over the area. Suddenly they both heard loud footsteps running across the landing. They hurried up the stairs to investigate, finding the lights on, the bedroom doors flung open and the lights in those rooms switched on too. Yet there was no sign of anyone and there certainly was no evidence of anyone entering or leaving the building.

The lights in those rooms were switched off, the doors that had been opened were then locked as a precaution against the possibility of an intruder being in the building, and the proprietor was called. He arrived very quickly with his dog and a thorough search was made. As they went upstairs they found that those rooms that had been locked were now flung open and the lights that the deputy manager had switched off were back on. The dog became very excited and darted in and out of the rooms as though she was following a scent, but no one was ever found. The hotel was empty. Or was it?

Two years later on Christmas Eve, or the early hours of Christmas Day, the festive season's celebrations were beginning to abate. The streets had fallen silent. Neath was beginning to sleep. Christmas Day was again a day off in the hotel's calendar. The assistant and duty managers were bringing their work to an end and were sitting in the reception area. The silence of the hotel was rudely broken by the sound of someone – or something – running across the upstairs landing. There was no one else in the building and, following a full search, no one was found on the premises. But, as in 1998, were they actually alone?

Edwardian Boy

On several occasions the night porters have reported seeing a boy dressed in Edwardian clothes roaming around the Castle Bar. There is no explanation for this sighting. The lad

causes no harm and looks mortal, but disappears from sight the second you look away. Look back to where he was standing and he is gone.

Lady in Black

One of the most persistent hauntings is that of a tall lady dressed entirely in black. She has been seen late at night, walking down the main staircase and out through the main door. The doors seem to fly open without being touched and the woman disappears into the street.

Disturbances

It seems that the ghosts in the hotel don't like any alterations being carried out to the structure of the building. During a recent hotel refurbishment, glasses were seen flying from shelves at the rear of the bar – the original site of the Nelson Bar.

The Cellars

The cellars under the restaurant area of the hotel were once used as the living quarters for the servants. These rooms haven't been used for many, many years and are now only accessible via trapdoor. When you descend into them you can see clear evidence of the beginning of what is believed to be a tunnel that connects to the River Neath.

The arch at the beginning of the tunnel was filled in with rubble years ago, and most of the rooms in the cellar are filled in with rubble or have been bricked up. One of the reasons promoted for the use of the tunnel is that it was used to smuggle wines and rum, etc., from the river to the hotel. Naturally, it is now dank, dark and unwelcoming.

Diners in the restaurant have, on occasions, mentioned that they thought they heard the sound of a dog howling. In the past there were stories of people seeing a wolf-like creature (probably a large dog) wandering around the cellar area when it was in use. Regardless, the dinners' appetites do not diminish, and they continue to patronise the hotel.

The Headless Cavalier

This is a very recent sighting. Pat Ellis, the manager of the lounge and restaurant, told me that a gentleman in his mid-seventies was sitting quietly by one of the tables near the front windows in the lounge drinking coffee and reading his newspaper. The area was reasonably quiet on that afternoon. Pat said to her – and you wouldn't imagine that he was given to making extreme statements – that he had seen a seemingly solid figure of a man sitting on an adjacent table dressed in seventeenth-century clothes.

Pat told me that he had said he was reading the paper and out of the corner of his eye he saw the feet of this figure and immediately thought it strange. His eyeline moved higher and when he got to this figure's neck it appeared that he was headless. The gentleman then lowered his paper in surprise to get a better look and as looked at it the apparition disappeared.

Pat said that he wasn't fazed by the experience and still regularly comes into the lounge for his coffee and to peruse his newspaper.

James Rees, the proprietor of the Castle said that this was the first report of this particular ghost.

The Nelson Room
There is no reported haunting in what was called the Nelson Room – so named because Lord Nelson actually stayed a night in the room. The room is now dedicated to the Welsh Rugby Union and has been renamed the Centenary Room.

The Baying Hound
The sound of a baying hound has been heard at various times over the years. The sounds of this hound, both mournful and aggressive, emanate from the cellars. This cavernous area is painted white, has large heating pipes running near the ceiling, and has several rooms and passageways, one of which leads to a bricked up archway. Intriguingly, no one seems to know what is located the other side of the arch, but clearly years ago it went somewhere and for some purpose. Mr James Rees said it had always been bricked up during the time his family had owned the hotel. A suggestion to remove some of the bricks to satisfy a curiosity was laughed aside. As James said it leads in the direction of the River Neath, we'll leave well alone, goodness knows what we'll find. But there is no issue with it as it is. It won't be moved.

But it is from this general location that the sounds of the baying hounds are heard. Did the tunnel once give access to the river? If so, was the purpose to smuggle illicit liquor from the ships that berthed at the wharf downriver from the bridge? Was the hound abandoned by the smugglers who perhaps had to leave the town in a hurry with the customs men chasing them after unloading their goods? Had the hound left to roam the area between the river and the hotel for eternity? All are questions trying to understand why the hound is occasionally heard howling or crying out, waiting to rejoin his ship mates. We'll never know. But as James Rees said, with a shrug of his shoulders, 'Who knows, but as long as he stays down here in the cellar and doesn't climb the stairs we'll be happy.'

But, maybe one day, eons into the future, someone might excavate the passageway and find the rotting bones of our canine friend.

The Man in the Lounge
Yet another recent appearance of a ghost in the Castle Hotel. Bar manager, Amanda Llewellyn, walked into the lounge and busied herself clearing glasses and as she turned she saw, standing by the bar, the figure of a man dressed in a tunic with silver-coloured buttons down the front; he wore dark clothes and sported a black beard. He was looking at her and, as she continued turning, her immediate response was to apologise to him for walking into the room without acknowledging him. 'I said I was sorry, I didn't see you there,' said Amanda.

And then in front of me he disappeared. I wasn't spooked, just shocked. He wasn't threatening in any way, he just stood there as though he was waiting to get served.

When I mentioned this experience to other members, some of them admitted they too had seen him. Before I started working here I'd heard that it was haunted but that didn't worry me, and it still doesn't, but now I know that this old place clearly has a past that many customers or staff will not let go off.

The Phone in the Boardroom

James Rees, the proprietor's son, told me about an incident that occurred recently concerning the telephone in the boardroom. This room is located on the first floor of the hotel. When the phone is being used in the room, like the phones in all the rooms, a light indicates its use at the reception desk. One evening the light came on, informing the receptionist that the phone was being used. James was near the desk and the receptionist asked him why the boardroom was being used at this time in the evening. He said it was not being used and he had closed and locked the door himself only a short time ago. 'But the light is on,' she said.

James asked the security men to accompany him to the room and even as they hurried up the stairs the phone light remained on. Within less than half a minute they arrived at the door and, sure enough, as James had said, it was locked. The security man unlocked it and the door was thrust open. It was in complete darkness, the phone resting in its cradle, when suddenly a gust of wind blew past them, followed by an eerie stillness.

Almost together they asked, 'What was that?' They couldn't explain it. There was certainly no one in the room, yet the record of the phone's use in that room at that precise time indicated that it been in use. But unfortunately the phone record doesn't tell us who had made the call or to whom the call had been made, it just records that the line had been active. And the gust of wind...?

11. Neath Market

The market moved to the present site in 1837; prior to that it had been held on the streets of Old Market Street (then called High Street). The market was growing and was occupying Butter Lane, Duck Street, Cattle Street and Cow Lane. It was moved because it was generally felt by the council that the business would be better placed for the townspeople near the animal market, which was held on the Parade.

In 1835, an Act of Parliament was secured and received royal assent on 3 July 1835 to relocate the market to its present site.

William Whittington was granted the building contract, the land having been acquired from Henry Grant, William Weston Young and David Powell, who submitted the lowest tender of £1,650.

When it was opened in 1837, it had a cobbled floor and stalls were arranged around the inside walls with a cross section of stalls through its centre; only the stalls near the walls

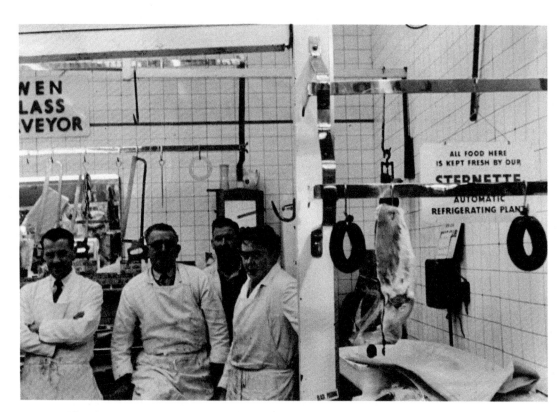

Local butcher Ken Own (in the centre) in his shop in Neath Market in 1963.

were covered. In 1872, the council erected stalls in Chalesville Place, which were later incorporated into the main building.

In 1877, the building was subject to radical alteration when the whole area was roofed. Following this development, social events were held in the middle of the area, these ceased when the Gwyn Hall was opened in 1888. In 1904, the entire market was rebuilt at a cost of £8,000, John Goodridge & Son, a Neath contractor, carried out the work. The main entrance is on Green Street and the seal above the door represents the Neath Corporation. Work in 1999 included a new roof and general maintenance to the wall on the Green Street entrance.

It is a typical example of the Victorian market that can be found in many parts of Wales – Swansea, Aberdare and Maesteg to name but three.

The atmosphere inside the market has always had a friendly ambience; in earlier years the stall holders were family businesses that spanned generations. The faggot and peas stalls are renowned for their quality; before and after the Second World War the stall that sold Welsh flannel plied a lucrative trade with people from both the Dulais and Neath valleys arriving in the town on Market days by bus and train. This, coupled with the farming community who had gathered in town to sell and buy animals, meant the entire streets were teaming with shoppers – nowhere was busier than the Neath Market. These were the high days of trading in the town. In recent years there has been a downturn, in line with that felt by high street traders. Nevertheless, the pleasant surroundings and cheery atmosphere still abides in Neath's Victorian Covered Market.

12. Neath Abbey Speedway

Leslie Maidment had taken speedway racing back to Cardiff and was keen to expand the sport, so he looked further west than Cardiff and applied to build a track on disused land at Neath Abbey in 1951. Freddie Williams, born in Port Talbot and World Champion in both 1950 and 1953, planned to run a training school there.

The post-war boom in Speedway was in decline and the track was never completed. Though it did host stock car racing in 1955 with Derek Walker, it lasted for just one season. The track also accommodated horse racing in the form of trotters. This, too, lasted for just a few months.

In 1962, New Zealander Trevor Redmond saw the potential of the track and planned to form a team to race in the provincial league. Trevor was dedicated to the project and acted as promoter, manager and rider. He had to overcome various obstacles in preparing the track, living in a caravan with his wife Pat and a young daughter on the course. He planned the first meeting against the Wolverhampton Wolves on 21 April 1962 but was thwarted by an attack of smallpox in the area. Redmond pressed on with his plan but again was held up because on 21 April that year a torrential storm forced the meeting to be called off. However, two days later, on 23 April 1962, the Neath team, called the Welsh Dragons, made its debut on Easter Monday at Cradley Heath. Redmond won Neath's first race but the match ended with a defeat for the Welsh team by 46 points to 32. The Neath team included Glyn Chandler and Jon Erskine.

On 28 April 1962, Neath Abbey heard the first roar in anger of the Dragons when some 3,000 people crammed into the stadium opposite the Neath Abbey ruins to see the Dragons win a match against Sheffield by 41 points to 37.

In 1962, the first match in the provincial league was held at Neath Abbey, where the Dragons hosted Cradley Heath, with the Welsh team losing by 34 points to 44.

Crowds were diminishing and support faltered despite the Dragons winning some matches and in mid-summer the Dragons relocated to St Austell in Cornwall where they had a ready holiday support. The team renamed itself as the St Austell Gulls (incorporating the Welsh Dragons).

The relocation to Cornwall had helped the side find some form, and when it arrived back at Neath Abbey on 4 August for a match against Poole they were challenging for the championship.

The last speedway meeting was held at Neath Abbey on 1 September 1962 where the home side beat Sheffield 41 points to 36. They ended up being runners-up behind Poole. A remarkable project that failed to find public support lasted for just one season. Neath won fourteen of their matches and drew one out of the twenty-four competed in – a very good record by any standards for a first season team.

Some of the names associated with the Dragons are Brian Leamon (manager), George Major, Jon Erskine, Charlie Monk, Trevor Redmond, Roy Taylor, Howdy Cornell and Glyn Chandler.

Racing was never to take place on the site in Neath Abbey, previously there had been stock car racing and trotting races held there. Following the demise of the Dragons and some years later, the track was developed as part of an industrial site.

13. The Tennant Canal

The Tennant Canal opened for business in 1824, built without an Act of Parliament by George Tennant, who employed the engineer William Kirkhouse. The canal afforded a more direct and profitable means of carrying minerals from the Vale of Neath to the larger vessels who entered the ports of Swansea. Prior to this the minerals were carried from the valley areas to the wharfs of Briton Ferry.

The Tennant Canal is lock-free (save for one at the lock house on the Aberdulais Aqueduct) and is 12 miles in length terminating at Port Tennant in Swansea. Thus, George Tennant's name is perpetuated.

The development of this canal incorporated the Glan-y-Wern Canal constructed in the late eighteenth century by Edward Elton and cut a swath near Crymlyn Bog; the object being to transport cargos from the Neath Canal via an estuary lockgate to Swansea. This canal closed in 1818 only to be reused, with added engineering work, during the construction of the Tennant Canal.

During the 1930s, the canal virtually closed in respect of carrying minerals and was primarily used as a water supply for industry.

Walking along the canal, we'll see en route social graffiti that dates back some thirty years; the railway bridge; the stone bridge leading towards Cadoxton Church (the story about the Murder Stone features here); no evidence of the pill (a short link-canal) leading from the Vale of Neath brewery to the Tennant Canal but you'll see the location; the tunnel (the only one of the canal) leading under Bridge Street. Here the bargees would have 'legged' their barges under the road. The site of St Giles Chapel is here too – now only a plaque commemorates the fact that this chapel of ease existed.

The Neath Canal was developed following an Act of Parliament granted in 1791, with the canal opening in 1795. It was built piecemeal with Thomas Datford being one of the principal engineers, although he moved on to the Monmouthshire Canal before the Neath Canal was completed.

Neath Workhouse
This is passed on the route back up the Neath Canal to Aberdulais the rear of the Bastille-like Neath Union Workhouse called Lletty Nedd opened in 1838, designed to accommodate 140 'poor persons'. Water would then be carried in buckets from the Gnoll. Later in that century, water for cooking was taken from the canal.

Tyn-Yr-Heol Lock House (Or Tonna Lock House)
This was constructed probably some years following the canal itself but is (or was) the last lock house to be used as a dwelling. It is currently for sale. The functions of the lock keepers were to open the lock and sometimes to collect tolls.

Aberdulais Tinworks.

Llantwit Church

Dating from around the 1400s and dedicated to St Illtyd, this is one of the oldest churches in the Neath area. Next door to it on the Llantwit Road side is Llantwit Cottage, which at various times lodged the luminaries William Weston Young and Alfred Russel Wallace.

Calor Gas

As we pass Calor Gas it's worth noting that originally on the site was the Mines Royal Copper works (1541) – one of the earliest copper refineries in Great Britain.

Aberdulais Basin

We end the walk at the Aberdulais Canal Basin. The skew bridge can be seen, along with the linking of the Tennant to the Neath Canal. The area was also used for the repair of barges. The aqueduct can be clearly seen. This structure was built over another canal or pill that linked the Neath River to the Dulais Forge – the current CADW site.

14. The Streets of the Town

Queen Street

This was the first Victorian street to be purposefully laid in the town. It was constructed from 1837 and was created to form a link to the covered new market, also built the same year.

DID YOU KNOW?

Queen Street was named as such to celebrate the beginning of Queen Victoria's reign.

From Orchard Street and beginning at the top of Queen Street, we encounter the commodious Queen's public house, now sadly renamed The Canterbury (I don't agree with changing of names of public houses). Next to it was the site of the British School, which was closed in 1899 and moved to the Gnoll School that once occupied the site of the new police station on Gnoll Park Road. Look up and above the topmost window and you can faintly make out in the stonework the words 'British Schools'. This school extended to where the Halifax Building Society is today.

Next door to the Halifax is the Masonic Hall, built in 1848. This building has no windows and above it is the emblem of the masons – the all-seeing eye. This 'secret society' is an international organisation and efforts are made by its members and hierarchy in these more enlightened times to make it less secret. Indeed, in Neath, and I assume elsewhere, tours are sometimes conducted through the building with information given about the aims and objectives of the organisation.

Towards the end of the street we come upon a jewellers and goldsmiths shop that once housed the Provincial Bank, which arrived in the town in 1920. Then we have the site of Marks and Spencer. This site has had several incarnations: Daniel Benbow had a house and soap works here; in 1804, the elders, deacons or the Baptist Union purchased the site for the building of Bethania Baptist Chapel. Access was from Green Street. A burial ground was developed for unbaptised children who had been shamefully denied burial in the parish church. The Baptists sold the building in 1866 after building a new chapel on London Road in 1862. Peter Davies, a draper, purchased the chapel with a condition that no development would take place on the burial ground. The Neath Philosophical Society – a forerunner of the Neath Antiquarian Society established in 1923 – developed

Queen Street.

Queen Street.

a library and museum in front of the chapel and by 1842 the organisation had built a tower to act as an observatory. By 1866, the museum and library was closed and the site occupied by Jones' Borough Stores. M&S appeared in the town in 1936.

The condition that the graveyard should not be disturbed by development was clearly lifted by clever barristers and now it lies underneath what was once the menswear department.

Between the jewellers and M&S was once a public right of way that afforded access from Queen Street to Orchard Street coming on to that street next to the Gwyn Hall. One can still see a boarded-up section of what was once a gateway. There was no gate when it was a walk-through area. This was lost sometime in the late 1960s or 1970s – another valued facility lost to the town. I remember walking through there with my father in the mid-1950s and one could still see the small stones marking the children's graves.

Green Street

At the bottom of Queen Street we face the market on Green Street. This street was originally called New Market Street; it was renamed in the early 1840s to Green Street because it led to what we call the Green area of the town on Commercial Street. The Green seems distant to the main town now but in the 1840s – with no railway, which came

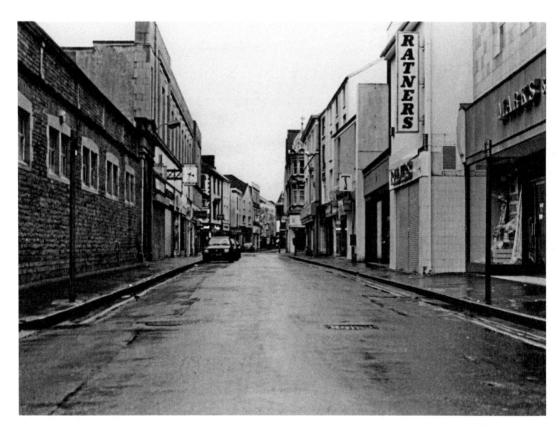

Green Street.

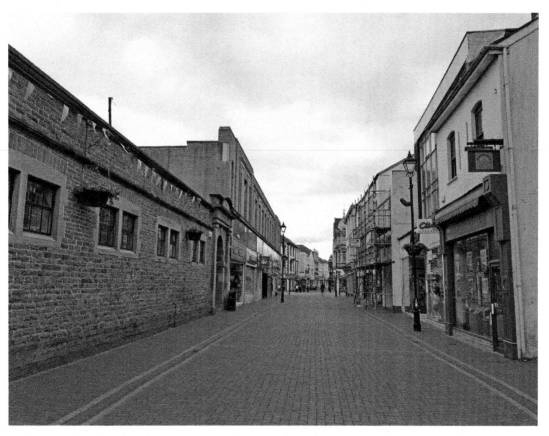

Green Street.

through the town in 1849/50 – it was a continuation from the town via the animal market on the Parade and past Maes-yr-Haf Chapel, whose graveyard covered some of the area on the Parade.

Green Street has many depictions on old postcards that show the buildings, including the Somerset Inn, said to have been the last public house to have a boxing ring. Above the shop now called The Works, we have a plaque showing Queen Victoria's head and shoulders with the date 1897 – the year of her Diamond Jubilee. Neath celebrated Victoriana.

From the animal market (part of which was colloquially called the Pig Hole) towards the Square and including the area occupied by the market, to the end of Green Street is the site of the Great House or, as a small plaque on the wall of what was once Burton's Men's Outfitters tells us, the Mackworth House. This was the home of the Evans family, into which Sir Humphrey Mackworth married. In 1543, it was the highest rated building in the town at 19s 4d per annum – in today's money that equates to a little over 95 new pence. This was an extensive building and part of the wall is still thought to exist in the yard behind the Castle Hotel. Orchard Street is so named because it was developed in the orchard of the Great House. This emphasises the extent of the property.

Queen Victoria above The Works.

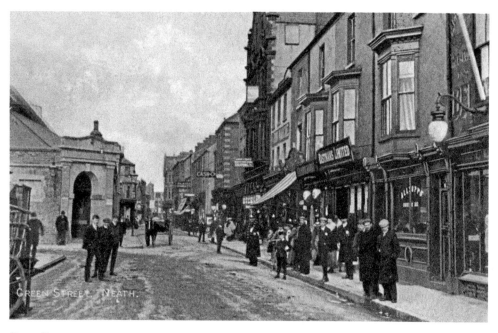

Green Street, c. 1900.

Green Street.

64

The Parade

Following the Pig Hole on the Parade we come to a small cul-de-sac called Charlesville Place, which is a remnant of nineteenth-century Neath. This street once extended to Green Street and ran behind the animal market.

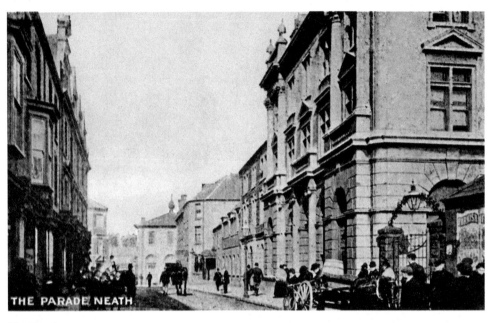

The Parade.

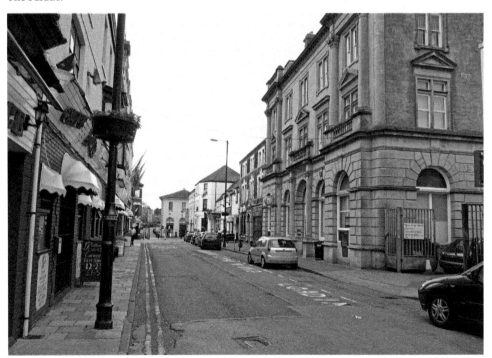

The Market Taven, a favourite watering hole of the visiting farmers to the town, has a mock Tudor frontage and ceased trading as a public house some ten years ago; it now operates as a café. The back entrance of the market abuts on to Barlcays Bank, whose building dates from the 1860s and is followed by the next significant property, the Castle Hotel.

Opposite the bank is the Ambassador, occupying the site of the Dorothy Hotel, an ironmonger and a betting shop. This line of buildings once was used as a spiritualists' meeting place.

Behind this row of buildings is a variety of business workshops that occupy buildings once used by the Castle Hotel during its coaching days for the stabling of horses and housing the mail coach on its night-time stop over at the hotel.

Bridge Street

This was the main thoroughfare into the town before the bypass and slip road sections. It is now a pedestrian walkway. The old river bridge dates from 1801. An earlier bridge replaced a wooden structure that collapsed in 1735. Zoar's Stores is on the site of Zoar Chapel, which had a graveyard behind the building, but there is no evidence of it today. The street housed several pubs and shops; there were shops in the archway under the bridge that carries the railway from Paddington to Swansea. I remember Mosses Stuart's barber's shop occupied one of the arches before they were bricked up. Mr Stuart then moved his business to another premises further along the street.

Bridge Street.

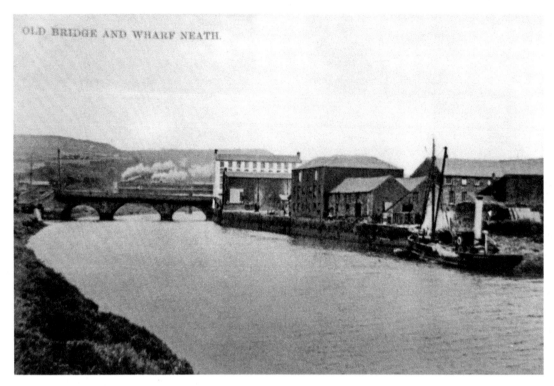

OLD BRIDGE AND WHARF NEATH.

The white multistorey building visible here is Isaac Redwood's tannery.

The street was also home to the old leather house, or the tannery, which was owned by Isaac Redwood. This was a large, distinctive white, multistorey building built on the edge of the river.

On the abutment of the bridge that spans both the River Neath, the Tennant Canal, and what used to be the Neath to Brecon Railway, is a stone plaque set into the wall telling us that this is the site of St Giles Chapel, probably a chapel of ease. Near this site was also Plas-y-Felin, the home of the Neath antiquarian Elijah Waring.

Quay Road turns onto Bridge Street near what was the Leather House, and the corner site was occupied by Mr Davies' Pickle Factory. Quay Street is virtually abandoned today but in the seventeenth, eighteenth and early nineteenth centuries would have been a bustling area, as ships docked there to load and unload their cargos. I remember seeing the large iron rings bolted into the side of the wall along the various quays that were used to tie the ships. Sadly such artefacts have disappeared.

Church Place

Church Place is now part of a conservation area. This street houses the commodious Old Town Hall, built in 1821 to replace the Guildhall in Old Market Street, which was demolished c. 1816. The upstairs of the town hall is used for meetings or various kinds of entertainment. Civic business was carried out there, but much of it (though not entirely) ceased when the Gwyn Hall was opened in 1888. The walls are adorned with many of the

St Thomas' Church, originally the castle's garrison chapel.

St Thomas' Church in Church Pace.

great and good of Neath's yesteryear. The buildings below or downstairs in the hall have been used variously as a corn market, a fire station and at some time in its life a place to hold criminals, possibly pending a visit to the magistrates. I remember in the 1950s/1960s metal bars on some of the windows clearly defining it as holding cells.

The Mechanics' Institute is further along the street, a building designed by the famous naturalist Alfred Russel Wallace, who spent six years living in the town. A monkey puzzle tree was planted in Victoria Gardens in 2013 to commemorate the centenary of his death.

The office of the solicitors' Jestyn Jeffreys was originally used as a Turkish bathhouse, and at sometime in its life possibly used, as in the case of other buildings below the Old Town Hall, as holding cells for the borough police. In the basement of the building are barred windows and a heavy wooden door that indicates its past use.

The St Ives is so named because of the trade between Neath and Cornwall. The buildings on this part of the street have two front entrances: what appears to be the rear entrance on Church Place, which faces the church, was deemed to be the most important aspect; and the entrance on Old Market Street where the hiring fair was held in the late nineteenth and early twentieth centuries was deemed to be equally important – thus the two frontal aspects to the buildings.

A plaque on the wall in the short walk through from Church Place – coming out on the junctions of Cattle Street, Castle Street and Old Market Street – tells us that this was the site leading to Cow Lane on of the long-lost streets of the town.

And, of course, there is also the Church of St Thomas the Apostle, after whom the street was named. The church is regarded to be the oldest building in the town that is still used for

The Old Town Hall, erected to replace the Guildhall on Old Market Street in 1820 – when the street was called High Street.

the purpose it was built. St Illtyd's Church can compete with that claim. St Thomas' was built as the garrison chapel to Neath Castle – the Norman's were devout Christians. It is dated to around 1283 and through the centuries has seen many additions to its structure. Burials haven't taken place here for over 100 years, and near the church door is a grave marked 'Do not open' indicating the occupier had died during one of the epidemics that swept through the town in the nineteenth century. The town stocks were in the front of the church and were where miscreants served their punishment. The stocks were in use until the 1860s.

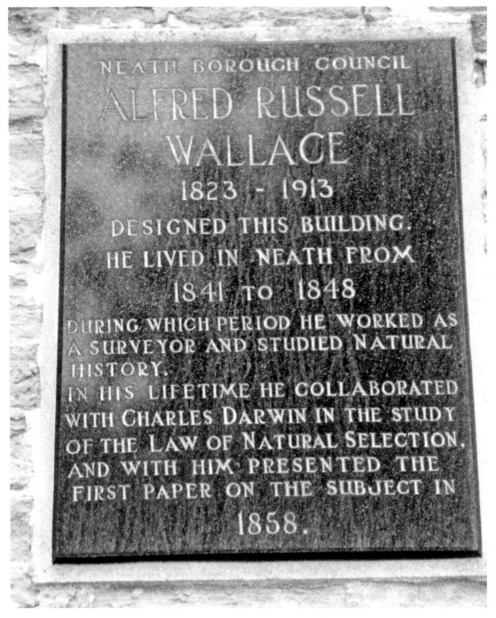

The plaque celebrating Alfred Russel Wallace's association with the town.

Castle Street

On this street is the entrance to the main part of the ruins of the Norman twelfth-century Neath Castle. The part of the castle we see from the supermarket car park was the gateway and was once the main access.

Also on this street is the Moose Hall. A plaque on the building's wall tells us that, in its days as a Wesleyan chapel, the preacher John Wesley visited. The building has also been used variously as a Methodist chapel, Catholic Church/school and a fire station.

Neath Castle. The entrance to the ruins is on Castle Street.

The Moose Hall, once a Wesleyan Chapel. It opened in 1813 and has been a Catholic school/church and a fire station.

The plaque on the wall of the Moose Hall indicating a visit by John Wesley.

Old Market Street

This street was originally called High Street because it was considered the most important thoroughfare in the town. Civic business was conducted from the Guildhall, an arched wooden structure that spanned the road. It was demolished around 1820 when the Old Town Hall in Church Place was built.

On this street during the hiring fair, one Margaret Williams presented herself for hire – people would offer their services as farm labourers or servants to the landowners, farmers, businessmen and even lower-middle-class townsfolk. Men and women who had travelled from the surrounding counties of Glamorgan and further afield would line up and hope to catch the eye of a prospective employer. In the early years of the nineteenth century they would work for 6d or 1s per year and their keep.

In Margaret Williams' case, her story has a dark, historical marker: the Murder Stone in Cadoxton Churchyard. She was a twenty-six-year-old servant girl from Carmarthenshire who was found dead 'in a ditch below the marsh' in 1826. The murderer was never brought to justice.

She had been taken on by the family at Gellia Farm, above the Neath Golf Course. One of her duties was to drive the cows to the marsh below the church for grazing. One day she didn't return and her body was found 'with marks of violence on her body'.

Old Market Street.

So incensed were the people of Cadoxton and the town that the antiquarian Elijah Waring was commissioned to write the epitaph on the headstone. It is damning and begins with the word murder, thus it has become known as the Murder Stone. It is located on the path leading to the church door and is legible. It isn't unique, there are several in Wales and one in Nebo Chapel in Felindre, Swansea is almost identical; the epitaph there was written by Waring too. However, because of its good condition, the Cadoxton Murder Stone remains the best example.

Back to Old Market Street. On the junction of the street with Cattle and Castle streets is the public house called the Elephant and Castle, and still on its original site is the Duke of Wellington (once called the Butchers' Arms), giving us an array of antiquated buildings, including the St Ives, some still with Victorian frontage. At the end of the street stands what once was the Globe Inn, with the unusual adornment of a bunch of grapes above the door and window.

Leading off this street is High Street, once called Butter Street, or Butter Lane, because butter was once sold there. Also we have the Mission Hall, again a commodious

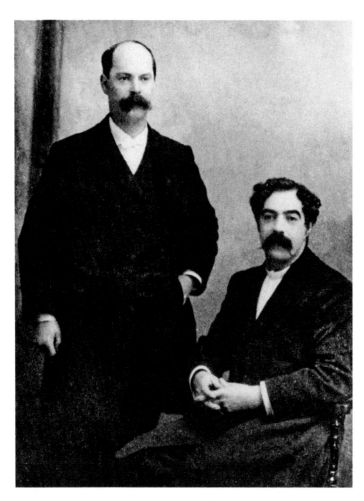

The Revds Seth and Frank Joshua.

building, where the preacher brothers, Frank and Seth Joshua, famous in Nonconformist ecclesiastical circles, held sway.

Seth Joshua was a prominent figure in the late nineteenth century and the early twentieth centuries; he was brave, loud and committed to the conversion of 'sinners' to the Christian fold. On those infamous Saturday nights, in the area of Neath we call Navvies Square (the area around the junction of Old Market Street, Wine Street and Water Street), as 'stop tap' time was called, the men who frequented the bars of the public houses would spill onto the streets – often intoxicated – and fighting would frequently ensure as differences were settled. A picture of mayhem. And in the middle of it all would be Seth Joshua, standing on a box loudly encouraging them to come to chapel instead and find redemption in Christ. He would be seen a lot on fair days, extolling the virtues of the Word.

It was this same preacher who attended a convention of religious gentlemen in Blaenannerch, Cardiganshire, who prayed to God, asking him to send a man, uneducated – he meant untainted by religious dogma – to lead us in the Word. The result of that convention was the rise of Evan Roberts of Loughor, who led the 1905 Methodist Revival. One can argue that that remarkable event began with thoughts developed in Neath.

The plaque on the wall of the St Ives public house telling us what had occupied the site in years past. Among the list of buildings and activities mentioned is that of a synagogue.

The Mission Hall on what was once Butter Lane, now called High Street.

One of the foundation stones on the Mission Hall hailing the name of Revd F. Joshua.

Wind Street

The well-known upmarket grocer shop Allin's stood on the site now occupied by Boots; the people, usually ladies who shopped here, would have chairs to sit on and be offered a cup of tea while being served by caring staff. The Social Service building built in 1868 was the William and Rowlands Bank, which became the Glamorgan Bank, then Capital and Counties Bank, and ultimately Lloyds Bank. Opposite was the Whittington's, a printer and stationary shop; part of the building is now used by Smith's bookshop and newsagent. The shop next door, albeit with the junction of Church Place between them, was Neath's first post office, hence the letter box inset into the wall – still in use today. The post office moved to Windsor Road in 1936, and then moved back again a couple of years ago. The Windsor Road site is now vacant save for the Neath Sorting Office on the upper floor.

Neath historian George Eaton surmised interpretations of the name 'Wine Street': wine was once sold there, it was a windy place, and was called Wyn Street in some historic documents.

Allin's, once an upmarket grocer. The site is now occupied by Boots.

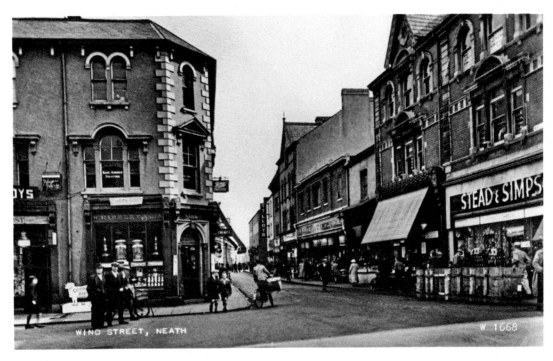

Wind Street.

This building was the first post office in the town – hence the, still-used, letter box on the wall.

The old Social Security Building, built in 1868.

Water Street

Water Street is named such because Gnoll Brook ran along the street, an open gully that was responsible for carrying deadly diseases. The brook is still there today but is

The Greyhound public house.

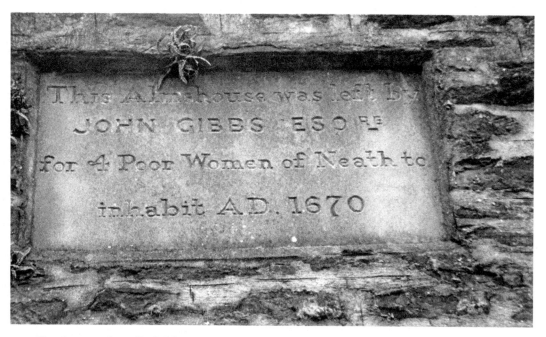

The plaque on the wall of Alderman Davies' School, where a house once stood for four poor women of the town, dated 1670.

The Shakespeare Inn – one of the pubs you could once find on Water Street.

Sadly, most of the pubs have disappeared from Water Street today.

now piped below ground. The street once had several public houses but now only the Greyhound remains – and that is said to be under threat from the City Fathers. The street was an amalgam of business premises and houses; those who lived there were passionate about their part of town.

On the wall of Alderman Davies' School is a plaque that tells us it was the location of a house for four poor women, courtesy of the charitable John Gibb.

New Street

This was once dominated by Phillips'. Also on this street were shops no longer there today, such as Sanders the tobacconist. The street still has an entrance that leads to the rear of the Castle Hotel. The cobbled stones on the ground are reminiscent of the old roads in the town.

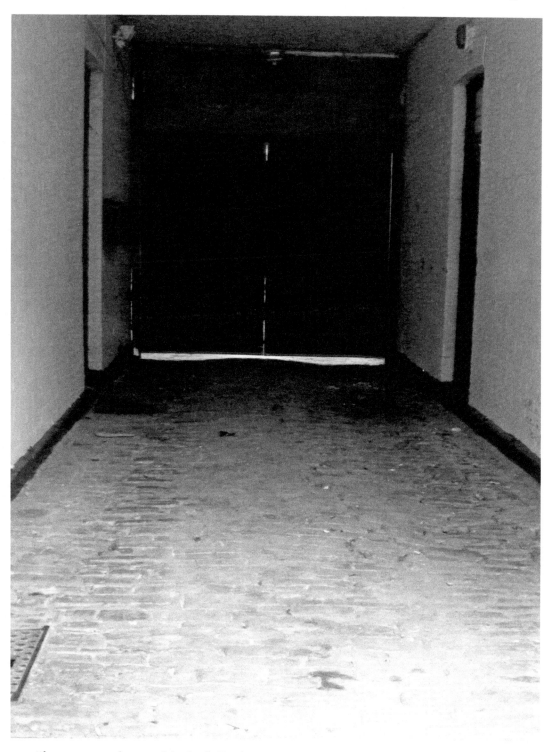

The entrance to the rear of the Castle Hotel.

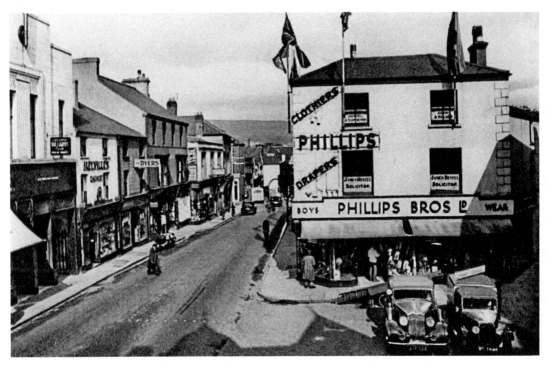

Phillips Bros Ltd on New Street, bedecked with flags.

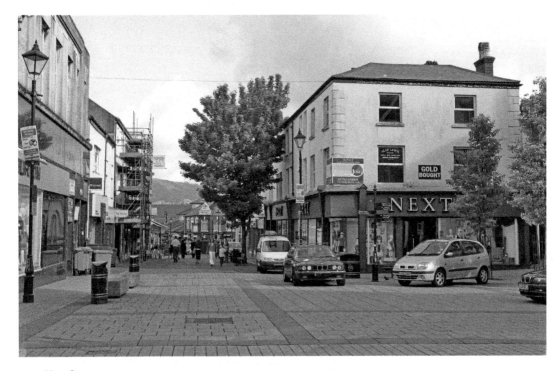

New Street.

The Gwyn Hall dominates this picture; on the extreme right is the Constitutional Club.

Orchard Street

Gwyn Hall is the dominant building in this street. It opened in 1888 and was built on land given to the town by the landowner, Howel Gwyn. His statue, the only one in the town, used to stand outside the building but now adorns a place in Victoria Gardens. Gwyn was responsible for donating the land for the Constitutional Club and church. Next to the Constitutional Club was where the offices of the Neath Rural District Council once stood. The Rural Council was amalgamated into the Borough Council during the reorganisation of local government in 1974.

St David's Church

This is the most visual of all the buildings in the town. The church is the work of the architect John Norton. It was consecrated in 1864 to serve the spiritual needs of the growing English-speaking population, then arriving in the area seeking work. St Thomas' existed before the Reformation and served the needs of the Welsh-speaking congregation.

The Vaughan Tower was a gift or major subscriber by the Edward Vaughan family of Rheola House in the Vale of Neath. The plaque at the foot of the tower is a memorial to those from the town who were lost during the First World War.

THE CLOCK AND CHIMES
WITH
A PEAL OF BELLS
WERE PLACED IN THE TOWER
OF THIS CHURCH
TO THE GLORY OF GOD
AND
IN HONOURED MEMORY
OF THE
MEN OF THIS TOWN
WHO FELL
IN THE GREAT WAR.
1914~1918

The plaque to those lost from Neath during the First World War.

Rheola House, Vale of Neath.

James Street and the Latt Area

The names of Glamorgan Street, Russell Street, Cow Lane, Duck Street, the Latt, James Street and Cattle Street have been obliterated from the map of the town, with the exception of Cattle Street, which exists in name only. This area is roughly where the superstore car park is and was reclaimed and occupied by the ring road, an area that was once used as a refuse tip and later where the fair and visiting circus were held. The fair was moved to the Millands car park as the local authority was not obliged to provide a place for the circus. There is an excellent Antiquarian Society video showing the demolition of the buildings in this area in graphic detail.

This was a vibrant area, albeit with poor housing, which was made up of some of the oldest habitations in the town. In this, the old part of the town, joined closely by Old Market Street, the hiring fairs existed. The names of the streets indicate what was happening on them; for example, Cattle Street was where cattle were sold. A bullring and a borough gaol were built in this vicinity in 1832.

In the wall, just before you climb the stone steps leading to the Roundhouse Café, a time capsule was placed with items that reflected life in the town in 1989. It was accompanied

THIS WALKWAY HAS BEEN FORMED

ON THE APPROXIMATE SITE OF

THE FORMER COW LANE WHICH FIGURED

N THE CATTLE FAIRS OF THE 19th CENTURY

This plaque is on the wall of the walkway joining Church Place with Cattle Street, indicating the location of Cow Lane.

The plaque marking the location of the time capsule.

by a brass plaque that was stolen a few years ago, leaving now a bare wall where the plaque was sited. The plaque read:

NEATH INNER URBAN SCHEME
This plaque marks the position of a Time Capsule
Containing document records and products reflecting the life in
Neath in 1989
The capsule was placed here by His Worship the Mayor of Neath
Councillor John Warman
On 20th February 1989 on behalf of
The Neath Borough Council and Pearce Developments Ltd

The Society of Friends – Quakers, so called because they quake before God – occupied (and continue to occupy) the building called the Friends Meeting House, which was built around 1799–1801. It is one of the few original meeting houses in Wales. Inside the building is altered insomuch as the balconies have been removed, but the exterior remains largely untouched. Personally, I find the adjacent graveyard one of the most peaceful places in the town. Here all the great and good of the town's Quaker community lay at rest. The headstones are simple with only a name and dates, and are lined along

The Friends Meeting House.

The plaque marking the Friends Meeting House.

Headstones from the Quakers' graveyard – Joseph T. Price.

Cwn Clydach, Neath Abbey. In the background you can see the cottages built by Joseph T. Price to house workers at his company.

Elijah Waring, died 29 March 1857.

Frederick J. Gibbins.

The family of William Weston Young.

the wall to protect them from any further weathering. Quaker tradition denotes that a headstone marking a grave should lay flat to the ground; nothing should protrude, in death, above God's earth.

One of the gravestones belongs to J. T. Price, the manager of the Neath Abbey Iron Company. He was a philanthropist and one of the founders of the Peace Society. He was involved in, unsuccessfully, having the death sentence commuted in respect of Richard Lewis (aka Dic Penderyn) who was hanged in Cardiff on 14 August 1831 for the part he is said to have played in the Merthyr Uprising. Many of us believe he was innocent of the charge for which he was executed. Price died on Christmas Day 1854

Another stone belongs to Elijah Waring, who died on 29 March 1857. Waring lived in Plas-y-Felin, now under the Neath bypass. He was a respected antiquarian and the author of the epitaph on the Murder Stone in Cadoxton Chuchyard. He was friendly with Edward Williams (aka Iolo Morgannwg) and the poet Robert Southey. Waring was married to J. T. Price's sister, Deborah.

The Parade
The road leading off the Parade is where Zoar Maes-yr-Haf Chapel is located, now with only a small section of graveyard. The graveyard once extended to the immediate area. In this chapel's records are the burials of the parents of the father of the North American coal

The Market Tavern.

and iron industry, David Thomas, or as he is affectionately remembered in the industrial history of the USA, Papa Thomas.

He was born in Tyllwyd Farm, Tyllwyd, Bryncoch, and served an apprenticeship with Neath Abbey Iron Co. After finishing his apprenticeship, he became the manager of Ynyscedwyn Iron Works in Ystradgynlais. While there he realised that by blowing hot air into a fire it flared and gained heat much more efficiently than blowing in cold air. He perfected this process. In his forties he was invited to the United States to resurrect a failing iron trade. He set up home in the Lyhigh Valley in Pensylvania and developed the industry into a successful enterprise. Thomas died in 1883.

This area of Neath once held the animal markets. Where Specsavers is now was parochially called the pig hole and across the road the cattle were held in pens, often nuzzling you through the fence as you waited for the bus. The Market Tavern, a favourite haunt for members of the farming community on market days, is resplendent in its mock Tudor façade.

Green Street

This street was called New Market Street in 1837 and was changed to the present name in 1840. It was called Market Street because the newly enclosed produce market had been

Green Street.

built there and opened in 1837. The location was deemed to be a more convenient place closer to the animal markets. The name was changed and Green Street merely means it led to the Green area of the town where the Victoria Inn stood, now renamed the Dark Arch or the Arches. The London to Swansea railway came through the town in 1849/50 and the tunnel walkway was constructed that dissected the area called the Green from the rest of town. Why it is called the Green is a mystery.

St David's Street
Standing next to St David's Church is Alderman Davies' Church in Wales School that was opened in 1858 from a gift of money left by Alderman John Davies, a local baker who died in 1719. A plaque on the school's wall tells us that the building was erected on the site of the Mera Village that existed in the eighteenth and nineteenth centuries.

The excellent book published by the Neath Antiquarian Society in 1980 carried a picture of Nell Downey, who was called the Queen of the Mera. I'm proud to say that she was my great-great-grandmother and that I am one of the many hundreds of the descendants of John and Nell Downey. John Downey was a harpist and frequently played for Madame Adelina Patti when that esteemed opera star performed concerts at Craig-y-Nos.

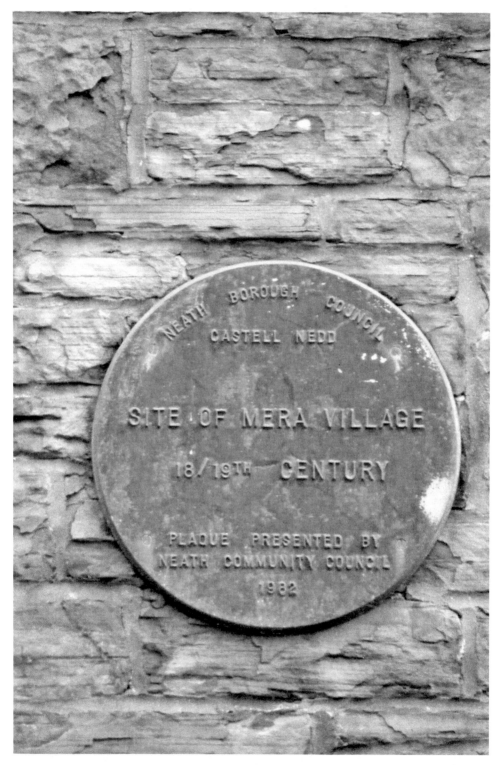

The plaque indicating the site of Mera Village.